THE
GREAT
VICTORIAN
COLLECTION

BOOKS BY
BRIAN MOORE

The Lonely Passion of Judith Hearne
The Feast of Lupercal
The Luck of Ginger Coffey
An Answer from Limbo
Canada (with the editors of *Life*)
The Emperor of Ice-Cream
I Am Mary Dunne
Fergus
The Revolution Script
Catholics
The Great Victorian Collection

The GREAT VICTORIAN COLLECTION

BRIAN MOORE

MCCLELLAND AND STEWART LIMITED

McClelland and Stewart Limited
The Canadian Publishers
25 Hollinger Road, Toronto

For Jean

THE
GREAT
VICTORIAN
COLLECTION

1

There is still some confusion as to when Anthony Maloney first saw the Great Victorian Collection. Can it be said that he first envisaged the Collection in his dream? Or did he create it in its entirety only when he woke up and climbed out of his bedroom window?

Maloney himself proved an unsatisfactory witness on this point. He was, of course, confused after the event. Indeed, he seemed a different person from the ordinary, rational young man who had checked into the Sea Winds Motel in Carmel-by-the-Sea, California, on that extraordinary night.

That ordinary young man was twenty-nine years old and an assistant professor of history at McGill University in Montreal. It was his first trip to the West Coast. He had flown out to San Francisco to attend a seminar at Berkeley. On the last day of the seminar, he rented a car and drove south, intending to spend the weekend exploring the Big Sur region. He arrived in Carmel on a

Saturday afternoon. On Monday he was to fly home to Montreal.

But Maloney did not make his flight. A year later, he was still living in Carmel in the same motel room he had checked into on the night of his arrival. A wall had been removed so that the adjoining room could be used as a study. But, in essence, his motel bedroom remained unchanged.

A word about Carmel. It is a small California coastal resort which is sometimes described as an "artists' paradise." But even on that first evening, walking past galleries filled with local paintings, arcade shops selling homemade candles, and bookstores displaying the complete works of Kahlil Gibran, it occurred to Maloney that a true artist could hardly fail to be appalled by the values evidenced in this place. Indeed, later, he became irritated when the Vanderbilt University researchers purported to find significance in his choice of Carmel and the Sea Winds Motel. The truth is, he stopped in Carmel because he had been told it was a convenient jumping-off ground from which to explore the Big Sur region. As for his selection of this motel, when he arrived in Carmel he had gone into a Chamber of Commerce tourist bureau and inquired about accommodations. A clerk in the bureau recommended the Sea Winds.

Maloney arrived there shortly after 5 P.M. Henry Bourget, the motel owner, greeted him in the lobby and showed him to a second-floor room. Maloney looked out of the window and saw a very large, empty parking lot, which fronted on Bluff Road. He asked if he should

park his car there, but Bourget said the lot was not in use, as it was about to be built on. He advised Maloney to leave his car in the street.

Maloney then brought his bag in. He inquired about restaurants and Bourget recommended the restaurant at which Maloney subsequently ate dinner. After dinner he returned to the motel, intending to retire early and be on the road to Big Sur at seven in the morning. He later said that when he entered the motel bedroom the blind was drawn and the bed was turned down. This has since been confirmed by Mrs. Elaine Bourget, wife of the proprietor, who customarily performs this service for guests.

Maloney was a normal sleeper. He had not had extraordinary dreams in the past. And, finally, his dream, as a dream, did not seem extraordinary to him at the time. To dream of Victoriana was not, given his background, an improbable conjunction. His Ph.D. dissertation had been "A Study of the Effects of Gaining a Colonial Empire on the Mores of Victorian England as Exemplified by the Art and Architecture of the Period." In connection with his thesis he had journeyed to England to visit museums and libraries and to look at various public buildings. Thus, while not a recognized expert on Victoriana, he could at least claim a degree of familiarity with the subject.

But, to return to the Sea Winds Motel. Maloney went to sleep in a normal manner and passed an uneventful night. Sometime in the early morning he awoke for a few minutes, then, falling asleep again, began to dream. The dream is given here as he recounted it in a television interview on the following day.

5

"I dreamed that I was in London having lunch at an old public house called The Cheshire Cheese, which is located just off Fleet Street. When I looked around I saw that the other people having lunch there were, unmistakably, transatlantic tourists like myself. I remember being irritated at finding myself lunching in such an obvious 'tourist attraction.' There was only one other customer who did not seem North American. He was a tall man who wore dark, old-fashioned clothing. I didn't see his face, but when he rose and left the room I felt compelled to get up and follow him. The waiter shouted out that I hadn't paid my bill, but I ignored this, went outside, and found myself in an ill-lit alleyway behind the pub. The man in dark clothes stood, waiting, with his back to me. I knew then that he had been sent to guide me. The man walked up the alleyway and, pointing to an oak door at the end of it, beckoned me to go ahead of him. I went to the door and pushed it open, believing it would give onto the street. Instead, I found myself in the darkened bedroom of the Sea Winds Motel, the same room in which I had gone to sleep. The bed was empty and the bedclothes were disarranged. I went to the window, raised the blind, and looked out at a pale pink sunrise. Below me was the motel parking lot, large as a city block. But now the lot resembled a crowded open-air market, a maze of narrow lanes lined with stalls, some permanently roofed, some draped in green tarpaulin awnings. I unfastened the catch of the window, opened it, climbed out on the sill, and eased myself onto a wooden outdoor staircase, which led down to the lot some twenty feet below. I began to walk along what seemed to be the central aisle of the market, an aisle dominated by a glittering crystal fountain, its columns of polished glass soaring to the height of

6

a telegraph pole. Laid out on the stalls and in partially enclosed exhibits resembling furniture showrooms was the most astonishing collection of Victorian artifacts, *objets d'art,* furniture, household appliances, paintings, jewelry, scientific instruments, toys, tapestries, sculpture, handicrafts, woolen and linen samples, industrial machinery, ceramics, silverware, books, furs, men's and women's clothing, musical instruments, a huge telescope mounted on a pedestal, a railway locomotive, marine equipment, small arms, looms, bric-a-brac, and curiosa. As I moved on, staring about me, I became aware that the stalls were unattended and that my guide had not followed me into this place. I knew then that all of this had, somehow, been given into my charge. And, as soon as I knew it, I woke up.

"It was morning. I was in the motel room I had dreamed about, that same room in which I had gone to sleep. I got out of the bed and, barefoot, wearing only my pajama trousers, went to the window, raised the blind, and saw that same pale pink sunrise. There, below me, just as in the dream, was the large open-air market and the maze of stalls occupying the entire area of the parking lot which had been empty last evening. I opened the window, climbed down onto the main aisle, and began to walk along that aisle, exactly as I had done in my dream, coming to the selfsame crystal fountain which I recognized now as the work of F. & C. Osler, a marvel of casting, cutting, and polishing of faultless blocks of glass, erected originally in the transept as the centerpiece of the Great Exhibition of 1851.

"I walked on. Everything in the stalls, booths, and showrooms was vivid and real. But I knew, of course, that I must be dreaming. There was no possible way that this lot, empty last evening, could have been filled

7

with so many large and varied exhibits in a single night. I remember that as I continued to walk I became aware that everything I laid eyes on was, in some sense, familiar. I stopped at a stall and picked up a small object, a child's wooden fire engine, circa 1840. I remembered I had seen it before in the Marvell Collection of Toys at Kensington Palace. I fingered the engine's painted surface, sniffed its faint odor, reminiscent of snuff, and put it back on the stand. I then noticed a mechanical cat sitting next to it, a tin toy which does not exist in any known collection of Victoriana. I recognized it from a description of its workings which I had read in a book on rare Victorian toys.

"But now I held in my hand a real toy, seven inches long, made of tin, painted with black and orange stripes, and containing a winding mechanism which enabled it to run along the ground on concealed wheels and, by a twist of its tin tail, roll over. When I wound it up and set it in motion I remember that, for one moment, I thought: What if it *is* real? What if I am not dreaming?

"I grew excited. I went quickly down the main aisle, discovering that each of the narrow, crowded side aisles contained stalls and sheds which displayed groupings of objects which themselves comprised collections within the Collection. A first, I stopped only at the very large pieces, such as the giant telescope which I recognized as the famous instrument designed by A. Ross; one of the more popular sights in the Great Exhibition of 1851. The locomotive I had noticed earlier was, of course, the South Eastern Railway Company's 'Folkstone,' designed by T. R. Crampton.

"In fact, it was as though I had memorized a huge catalogue. I recognized the 'Thebes' stool made for Liberty & Co. Beside it was a grand piano of walnut

8

with inlaid ornament of boxwood and mother-of-pearl made by John Broadwood and Sons, which, in turn, sat on a Hammersmith rug, designed by William Morris. All were from the 1880's. Near them was a clawfoot sofa of carved mahogany upholstered in red silk, about fifty years older, I believe.

"I had never seen such a collection. On the opposite aisle to these furnishings I noticed the 'Day Dreamer' easy chair in papier-mâché, decorated at the top with two 'winged thoughts,' and made by Jennings & Betteridge; an ivory throne and footstool presented to Queen Victoria by the Rajah of Travancore; a marquetry dressing table with botanical woodcarvings by Messrs. Trollope. I turned away and, in the maze of aisles, no longer pausing to examine individual pieces but simply roving among this glut of objects, came on collections of Victorian silver tea sets, bridal breakfast services, ornamental urns, statuary, cheval glasses, tallboys, ottomans, poufs, corner cupboards, gaming tables, stoves, kitchen utensils, fireguards and firedogs. Among the larger rooms I recognized the parlor of a famous Victorian brothel and a room containing the furnishings of a Victorian music hall.

"I moved on. I was walking down an aisle which reflected life in the Victorian streets, with a display of costermongers' barrows, carriages, penny-farthing bicycles, and so on, when, up ahead, I saw something move.

"It was a man. He was in his sixties, heavily tanned, with longish gray hair. He was outside, on Bluff Road, moving past the entrance to the parking lot, pulling behind him a metal trolley containing two green plastic garbage cans.

"The newcomer (I later discovered that his name is

9

John Rockne and that he lives down the road) stopped and called out in greeting: 'Hi there. What the heck is this, some kind of exhibition? How in God's name did they get it up so fast?'

"I remember that I did not answer him. There was something about him, some living reality, I suppose, which left me tongue-tied and alarmed. Again, the thought came into my mind: What if I am *not* dreaming?

" 'I just can't believe it,' Mr. Rockne said, peering in. 'Look at that fountain! And look—is that a locomotive, sticking up over there? Are you in charge of this?'

" 'Yes,' I said. I don't know why I said it. I simply said it.

" 'But there was nothing here yesterday. I came by yesterday evening. I just can't believe it.'

"I didn't answer him. I didn't know what to say to him. Besides, in a dream you don't have to behave politely. I smiled, then turned and walked back up the central aisle, passing by the fountain, which, I noticed, had water in its pool and a mechanism to turn on the jets. But I did not stop to see if it worked. I felt chilly. I was wearing only my pajama trousers, after all. I re-turned to my window, climbed up, and re-entered the motel room. At once, I began to dress in a great hurry, all the while staring out of the window. I saw Rockne move on, looking back at the Collection as he dragged his trashcans toward the garbage pickup point. Then, just as I finished dressing, two cars passed by on Bluff Road. Both slowed down and their occupants peered in at the Collection. And, again, the thought came to me: If those are real people and they see what I see, then I am not dreaming. I have made this Collection come to

life. No one has ever done anything remotely like it before."

In the television interview, Maloney then described how, at that point, one of the cars pulled over and parked and its occupants, two women and a small girl, got out and walked boldly into the parking lot, staring at the contents of the stalls. At once, Maloney grew agitated. If this was not a dream, the exhibits were completely unprotected from thieves and souvenir hunters. The lot must be fenced in and guarded at once. And so, in a hurry, not thinking of what he was going to say, he went out to the lobby.

Mr. Bourget had obviously not yet stepped outside that morning. "Hi there. Sleep well?"

"Yes. There's something I want to mention to you. There's a lot of stuff out there in your parking lot. It's quite valuable. I wonder if we could hire somebody, some private guards, to look after it."

"What stuff? What's it doing in my lot? I told you not to use the lot."

"I'm very sorry. I just had nowhere else to put it."

Mr. Bourget is a white-haired man who walks with a pronounced limp, the result of an injury to his heel while serving with the Seabees in World War II. He got up from behind the counter, took his cane, and went with Maloney to the parking lot. Later, describing his impressions in a newspaper interview, he stated that he was "bowled over by the beautiful stuff I saw out there." But, in truth, Bourget did not seem "bowled over" by his first sight of the Collection. He entered the parking lot and walked up the center aisle, gesticulating with his cane. "What's all this junk? How in hell did this stuff get in here? I don't believe it. A fountain! I've got to be dreaming."

"Well, maybe one of us is dreaming," Maloney said. "I think it's me."

"Who the hell gave you permission to stick this stuff in here?"

"I'm very sorry. It was an emergency."

"What emergency? How did you get all those structures up? You must have used fifty trucks."

"Well, I wanted to explain to you. These things are very valuable."

"Listen to me!" Bourget said, interrupting. "I don't know how you got it set up like this. And, come to think of it, I don't want to know. But if you got it in in one night, you can get it right out again, do you hear? I want this lot empty by noon."

"I know. I should have spoken to you. But I was wondering. Would you consider renting me the lot on a day-to-day basis?"

"No, sir. No way."

"I'd pay well. Just tell me what you'd consider a fair price."

There was a silence. Then: "A fair price? You mean a cheap price? Well, let's say a hundred a day, that's a dirt-cheap price. Because that's a big area you got there."

As he spoke, Bourget waved his cane in illustration, seriously endangering the delicate funnels of some rare "student" lampshades.

"All right," Maloney said. "I'll take it at a hundred a day."

"Just a minute. You can't put this on your Diners card. It's got to be cash. And in advance."

"Would traveler's checks be acceptable?"

"Come in the office," Bourget said.

There Maloney paid Bourget a two days' rental of two hundred dollars and, with his permission, phoned a

12

guard service, Securiguard Inc., and arranged for two uniformed men to be sent over at once at a daily rate of thirty-two dollars apiece. As the men worked eight-hour shifts and as at least one night guard must also be arranged for, Maloney estimated that even if he were to wire Montreal for his entire savings, he would be unable to maintain the Collection for more than two weeks.

The security guards arrived within the hour. Until they did, Maloney stood in anxious vigil at the entrance to the parking lot, turning away passers-by who wanted to come in and look at the exhibits. He no longer asked himself if he were awake or dreaming: indeed, he had no time for self-examination, being kept constantly on the move discouraging people from picking up objects, and providing evasive answers to such questions as: "What's it for? What sort of fair is it going to be? Where did it all come from? Who owns it?" and so on.

But as soon as the uniformed guards took up their stations at the lot entrance he became victim of a new anxiety. What if the Collection, which had appeared in a dream, were now to disappear again before he had time to prove to the world that it had actually materialized? With this in mind, he hurried into his motel room and telephoned Professor William Henning, his host at Berkeley. It was the first of many strange conversations he was to have with friends and colleagues.

"Bill, this is Tony Maloney."

"Hey, Tony, how's it going? Let's see. Where are you? Big Sur?"

"No, I'm still in Carmel. Listen, Bill, something has come up. I need your advice."

"What's your problem?" Henning asked and waited, silent in San Francisco while Maloney, stricken with

aphasia, was for some moments unable to formulate any reply to his friend's query. What could he say? Who would believe this unbelievable story? To mention it at all was like saying that you'd lost your mind. Thus, when speech returned to him, Maloney found himself mumbling, "Listen, I've come upon something, a collection of Victoriana—"

"That's kind of a hobby of yours, isn't it?"

"Well, yes. This collection is very interesting, very valuable. I'd like to get some pictures taken of it at once."

"Who owns it?"

"Well, in a way, I do."

"You mean you just got hold of it?"

"It's hard to explain over the phone."

"Got you," said Henning, in the voice of a man who appreciates sharp trading. "Still negotiating, are you?"

"No, not really. But it's such an important discovery, I mean—collection. I think perhaps I need some institution to sponsor it. You know, to fund it so that it will be properly looked after and displayed and so on."

"How about a commercial sponsor?"

"Well, no, I wasn't thinking of that."

"Shell Oil is doing a lot culturally. And so is Xerox. You'd be surprised."

"Well, I'm not sure what to do at this stage."

"Tony," Henning said, patiently. "If you've discovered some great Victorian collection, what you need now is publicity. If you get the right kind of publicity, things will begin to happen."

"Publicity?" Maloney said, his voice shaky with new excitement. "You're quite right. This is a fantastic news story. Hey, Bill—didn't you tell me your brother-in-law

works in the San Francisco bureau of *The New York Times?*"

Henning said, dubiously, "He does. But you know the *Times* is pretty picky about what stories it runs. They have to be—you know—of national interest."

"This is of national interest," Maloney said. "It's of *international* interest. Wait till they find out in London that this stuff has turned up here. Out of the blue! Believe me, Bill, your brother-in-law is going to thank you."

"So, you're really sure this is something big?"

"I'm certain."

"Well, I suppose I *could* call Jerry. But, listen, how should I explain it? I mean, the collection?"

"Just say that it's, ah, that it's *the* Great Victorian Collection, the greatest in the world. And that I've just discovered it in Carmel."

"And that you're a leading authority in the field."

"Well, I wouldn't say that."

"Tony, if you want to promote this you've got to go all the way."

"Yes, I suppose so. Yes, you're right."

"Okay, give me your number and I'll call you back."

Maloney read off his number, put the phone down, and went to the window. On the side of the parking lot fronting the street, one of the guards, armed with revolver and nightstick, stood with his back to the stalls and booths, watching the cars slow down as they passed by on Bluff Road. The second security guard sat on a chair in the middle of the main aisle of the Collection, shoulders slumped, hands hanging between his thighs in the abject posture of bored museum guards everywhere: jailers, themselves jailed, such guards had always

15

seemed to Maloney the personification of that public which, left to its own devices, could not be induced to walk ten steps to view any museum exhibit in the world. Indeed, there was something about a museum guard sitting in the midst of the Collection, a real toad, so to speak, in this imaginary garden, which reinforced his feeling that he was not dreaming: he had really created these things and had made them visible for others to see and admire. It had never been done before. It was unique.

At that moment, as he stood at the window, an idea came to him. If he was not dreaming, if he had been able to will these items to appear, could he now will them to disappear? Or—an interesting possibility—could he will them to appear somewhere else? What if, as an experiment, he willed one piece to move now, from the parking lot into his motel room? He shut his eyes. The first object which came to mind was the first item he had examined, the child's wooden fire engine from the Marvell Collection of Victorian Toys. He concentrated. *Make it move from its stall and reappear here on my bed.*

He opened his eyes. He looked at the bed. There was no toy engine there. A feeling of dread assailed him. Turning, he ran out of the motel, going straight to the parking lot and the booth where the Marvell Collection was on display. At first, as he ran up, his sensation was one of relief. The grouping was as before. The toy engine sat exactly where he remembered it to have been. But, on picking it up, he knew at once that something was wrong. It looked the same, but when he turned it over he saw, stamped on the forward axle, the words "Made in Japan."

He was absolutely sure that the words had not been

there when he first examined the engine. He scrutinized each of the remaining toys. The engine was the only imitation. He stood for a moment, looking at it in dismay, then covertly put it under his suit jacket and, retracing his steps, went back into the motel with some vague idea of destroying it. But although he could feel the bulge of the wooden toy under his coat, when he reached his room and sought to uncover it, the toy had disappeared.

His first reaction was joyful. Nothing could be more damaging to the status of the Collection than for a cheap Oriental imitation to be discovered among its pure period pieces. The fake seemed, simply, to have vanished into thin air. Of course, there was the possibility that, unwittingly, he had dropped it in transit from the parking lot to his room. So he retraced his route, coming once more to the Marvell Collection, where he saw, restored as if by magic to its original position, the selfsame wooden engine. And, on picking it up, read the same incriminating legend: "Made in Japan."

Then, and only then, Maloney realized the laws of this creation. Already the toy engine reproached him, a small cancerous blemish on the perfect bloom of the whole. It had been given to him to envisage the Collection here, in a parking lot in California. Any further attempts to remove these items to some other location would result, not in the greatest collection of Victoriana the world had ever seen, but in an astonishing conglomeration of Japanese fakes.

A few minutes after this experience, the telephone rang.

"Tony? This is Bill Henning again. I just talked to my brother-in-law."

"And?"

17

"Well, I think I was pretty convincing. Anyway, I got him to promise that they'll look into it. He said they're sending their Monterey stringer over to check it out. You going to be there for a while?"

"Yes. Did he say when they'd be likely to arrive?"

"No, and I didn't ask. You can't push these press people, you know."

"Yes, of course. Well, thanks, Bill."

"Not at all. And, listen, if you need any more help, call me at my office. Call me anyway, and let me know how you make out. Oh, and by the way, Peg says let's all get together for a drink, as soon as you get back to San Francisco. You're coming back through San Francisco, aren't you?"

"Yes. I think so. And thanks again, Bill. I really appreciate this."

"Okay. Take care."

Maloney put the receiver down and went to the window, staring once again at those roofs, sheds, and awnings. For a long time he stood as though in trance, remembering with a shiver of recognition that he had once thought of creating a collection such as this. It was in his graduate student days, after his return from England. He had asked his adviser about the possibility of the Canada Council's funding a research study to investigate the possibility of assembling a National Collection of Victoriana. "Impractical," his adviser said. "You would have to start by finding some collection and a donor willing to present it. You'd have to have promises of further funding from private sources. And nobody has that kind of loot any more."

And so he had done nothing about it. Or had he? Now, staring at this strange reality of an old dream come true, he realized that it was, indeed, his responsi-

bility. He could not abandon these objects. He must stay here and watch over them.

But at once, in counterpoint, new glooms of guilt arose. The face of his wife, Barbara, loomed like an angry icon, reminding him that on Wednesday he had promised to meet her in Montreal. They were to have coffee in the Café des Arts, and a talk—the long-awaited talk. It had been more than a year since Barbara had walked out on him. They had not met or spoken to each other since.

No, he would have to go back. He had made a solemn promise to Barbara's sister, who had been the intermediary. He *must* show up on Wednesday. That was the all-important meeting. If he stayed on here over Wednesday, any possibility of fixing things up with Barbara would vanish like a dream.

So that was that. Real life. The Collection was wonderful, it was beautiful, it was absolutely astonishing. But, once he had it photographed and authenticated, he would have to head home. No question about it.

The telephone rang. "Professor Maloney? This is the desk. I've got a gentleman, says he's from the press. Will I send him in?"

"Yes, please."

He had expected someone older than himself. But the reporter, dressed like a student, in khaki bush jacket, jeans and red tennis shoes, was probably five years younger than he. Plump, with whitish blond hair worn fashionably long about his shoulders, the visitor stepped into the room, did not speak, but at once handed Maloney a small visiting card, much as though he were a deaf-and-dumb beggar soliciting alms. He watched with a cold blue stare as Maloney read the card.

"I am also the local correspondent for *The New York Times*."

Maloney asked him to sit down.

Vaterman sat on the bed. He produced a notebook and a ball-point pen. "This morning I received a call from the San Francisco office of the *Times*. They tell me you claim to have discovered here in Carmel a fantastically valuable hoard of Victorian treasures. May I ask where these—treasures—are hidden?"

"They're not hidden," Maloney said, beckoning his visitor to the window. "There they are in the parking lot."

Vaterman stood, looking out. Sunlight rinsed his ash-blond locks, revealing a downy fuzz on his porcine cheeks. "My God! All of those stalls?"

"Yes."

"How many items would you say, roughly?"

"I don't know yet."

"Why not?"

"I haven't had time to count them."

"So. May I ask, where did you find these things?"

Maloney looked into those cold blue eyes. Of course, he would have to tell about the dream. That was the story. But how? He hesitated, then said: "Perhaps you'd like to go out and have a look at the stuff?"

"Later. First we will get the details, if you don't mind."

"All right," Maloney said. He felt himself grow tense.

"So, if you will begin at the beginning?"

"Well, I know this is going to be hard to believe." His

voice seemed to him disembodied, floating in the room as though spinning from a tape recorder. "But last night I had a dream. I dreamed I was having lunch in London—"

"London, England?"

"Yes. I was in a restaurant. A man who was lunching there, a man who wore old-fashioned clothes, got up to leave and, in my dream, I followed him out into an alleyway. He led me to a door in the alley and beckoned me to go through. I opened the door and found myself in a room. It was this room."

"Which room?"

"This room."

"This particular room," Vaterman said. He began to write in his notebook. "So?"

"So, in my dream I went to the window and looked out. There was the parking lot and it was just as you see it, all those stalls, all those objects. Then—and this is the astonishing part—then I woke up and got out of bed. It was morning."

"What time?"

"I don't know."

"You couldn't make a guess?"

"Oh, just after dawn. Anyway, I opened the window, climbed out and began to explore—"

"Why did you climb out of the window?"

"What do you mean?"

"Why didn't you use the door? You could go through the lobby into the parking lot."

"Well, I didn't think of it. I was excited. I mean, I couldn't believe my eyes."

"Could not believe his eyes," Vaterman said, writing it down. "And why could you not believe?"

"Why? Good God, man, this is the most fantastic collection of Victoriana in the world. There's nothing like it anywhere. What's it doing here?"

Vaterman smiled, warily. "Wait a moment. Let me, please, ask the questions. First, you are an established expert on this Victoriana stuff?"

"Well, it's a hobby of mine. I do know something about it."

"But your opinion of its value could be challenged by other experts?"

"Well, yes, I suppose so."

"So, it's possible, then, that this stuff could be ersatz? Imitation?"

The Japanese wooden engine jumped into Maloney's mind, causing his shoulders to contract as though in anticipation of a blow: this guilty movement, he felt, was not missed by Vaterman. "Well, hardly," Maloney said. "I mean, I recognize a great many, if not all, of these objects."

"How do you recognize them?"

"Because I've seen them in other collections."

"So they are stolen?"

"No."

"Then they are, or could be, copies?"

"Whether they're copies or not isn't the point. The point is, I dreamed them up and now they're here."

"Ah!" Vaterman said. He stopped writing. "Then, if they are here, they cannot be there?"

"In England? Yes, I suppose that's the logical assumption. But then, it would be an equally extraordinary thing, a telepathic theft, so to speak. Still, I don't think that's the case. I suspect these things exist *both* here and in England."

"Then one set is original, and one set is fake. You claimed these things to be 'fantastically valuable.' Yet, now you admit they might be fakes."

"Mr. Waterman, why do you keep missing the point? The point is, I dreamed them up and they've appeared here. Out there in that parking lot."

"Vaterman," Vaterman said. "With a *V*. Not like the pen."

"I'm sorry."

"That's all right. People often make this mistake. Now, to go back to what you just said. That is, don't you see, my problem. I mean, how do I explain this to my editors?"

"I realize that," Maloney said. "And let me say that if I were you and some stranger told me he'd dreamed this Collection into existence, I'd think there was a trick. I'd think he was some sort of crook or publicity seeker. I'd be just as suspicious as you are, but"—and here Maloney held up his hand, fearing that Vaterman would interrupt—"I want to say that this whole event baffles me as much as it does you. I mean, I don't know if this stuff is going to vanish again five minutes from now. That's why I got in touch with you."

"I don't quite understand."

"I need photographs and witnesses. I need someone to tell me I'm not mad or dreaming, don't I? Supposing it disappears again in the next hour or so? Then what? Nobody will ever believe it happened."

Vaterman nodded and stood up, putting his notebook and pen in his pocket. He smiled placatingly, then made for the door. "Will you excuse me a moment, Professor? I'll be right back."

The door shut. Maloney sat for a moment and then,

as though hypnotized, went once more to the window to stare out at the roofs and awnings. Where had the reporter gone? To telephone? To check something?

Quickly, Maloney went to his room door, opened it and peered out. At the end of the corridor, in the lobby, he saw Vaterman in earnest conversation with Bourget. There was a great deal of head-nodding and agreeing. Maloney shut the door. For a moment, he thought of locking it, climbing out the window, getting into his rental car, and putting as many miles between himself and Carmel as possible before the police or the asylum men arrived.

But, with a perfunctory knock, Vaterman re-entered the room.

"So," he said. "It checks out, so far. Fantastic! Yes, it has to be something like you said. It couldn't get set up in one night. But tell me. Why did you not say anything to the motel man about having a dream?"

"I don't know. I just thought he wouldn't believe me. He was pretty angry at me for using his lot."

Vaterman went again to the window and looked out. "*Who* will believe it?" he said. "Professor, may I tell you something?"

"Yes, of course."

"It is something about myself. First of all, the name Vaterman is well known in Bavaria. I come from a family which has a great tradition. You have heard, perhaps, of Oberammergau?"

"Where they have the Passion Play?"

"Exactly. My grandfather and my great-grandfather both played leading roles in the pageant. My father played John the Baptist. So, we are a family with achievements. And I, who am the first member of this family to become a citizen of the United States, have my

own dream of achievement. I want to become a great newspaperman in the American tradition. Like Jack London. Or Reston of the *Times*. Do you follow me?"

Maloney nodded. Vaterman reminded him of a graduate student. They never could come to the point.

"Anyway," Vaterman said. "Today, at long last, I have my chance. My editor, Mr. Yorkin, is the local correspondent for the *Times*. He is sick with flu and so I am covering for him. Sheer luck. But here is my problem. What are you, are you a nut or a crook, or am I sitting on a story so big that if it checks out all the way—my God! Do you follow me?"

"Of course I do," Maloney said. "Look, I'm in exactly the same boat. I can only tell you that this *happened*. It happened just the way I told it to you."

Distractedly, Vaterman ran his fingers through his ash blond locks. "Okay, let's assume for a minute that it *is* true. How am I going to keep it for myself? Exclusive. Excuse me, confiding in you like this. But you have a dream and I have a dream. How can we make both these dreams come true?"

"My dream *has* come true," Maloney said. "That's my problem. Now, I need to prove it. I need pictures to be taken at once."

"Pictures? Oh, my God!" Vaterman seemed transfixed. "May I use your phone to call the *Times?* All charges will, of course, be reversed."

"Go ahead," Maloney said. Suddenly, alarmingly, he felt drowsy. "I've got to step outside for a moment."

"No, better wait here. The *Times* office may have questions for you."

"I'm sorry. I *must* step out."

"You mean you want to go to the bathroom?"

"No. I need fresh air. I feel sleepy. Look. Normal

25

dreams disappear when a person wakes up. Maybe this Collection will disappear if I fall asleep again."

"Yes, that is possible, isn't it?" Vaterman said. "All right, you go ahead. I'll phone on my own."

Maloney went out of the room. As he crossed the lobby, Bourget looked up from his desk and called: "How's it going? Getting a nice write-up?"

He pretended not to hear. Hurrying, he reached the parking lot, and, pausing for a moment, took a deep breath, then began to jog along the aisles of the Collection, moving deeper and deeper into the maze. After a few minutes his drowsiness abated and, out of breath, he paused by a shed which contained an exhibition of oils and watercolors by Victorian Royal Academicians: landscapes, stormy seascapes, portraits, illustrations from novels of the day. Sentimental and literary, these paintings reminded him that in the time of the old Queen, something like this Collection would first have been announced to the world in a series of artist's drawings in *The Illustrated London News* as a marvel, a far-off miracle, to be accepted by most of the populace as yet another wonder. But, today, in this age of instant distrust, who would believe it? He knew then that he would be challenged, cross-examined, probed. His brainwaves would be monitored, his childhood investigated, his body fluids tested, his privacy destroyed. And for what?

At that moment, looking up from the paintings, he saw Vaterman, framed in the motel window above, talking excitedly on the telephone. Vaterman was talking to the *Times* about the dream. It would soon be public knowledge. Oh, God! The sensible thing to do would be to duck across to the entrance to Bluff Road, find the rental car, drive back to San Francisco, and take the first plane home to Montreal. And if they tracked

26

him down, he would simply deny he ever gave this interview. He would deny that he knew anything about the Collection or where it came from. It was the only sane thing to do.

But at that moment Vaterman threw open the window and shouted down, "Professor? They're sending a reporter and a photographer up by plane from Los Angeles. And they want to interview you."

He stared at Vaterman. Would *The New York Times* believe this story? What if they did not believe it? What would convince them?

He looked back at the Victorian paintings, alien and vulnerable under this metal American sun. This sun is a danger; it could fade those colors and diminish the paintings' claim to authenticity. There should be a larger tarpaulin on that stall. At once.

2

On that same afternoon Lieutenant Henry Polita of the Salinas County Sheriff's office arrived with his partner to investigate an anonymous complaint that a fairgrounds was being set up illegally in the motel's parking lot. Both were uniformed officers. They were shown at once to Maloney's motel room. Polita, a heavy young man with a sarcastic manner, chewed gum disconcertingly all through Maloney's explanations as though he, Polita, were silently mouthing obscene words of disbelief. From the outset he acted on the assumption that the Collection had been stolen. His first question was to inquire if Maloney was the owner of the objects in the parking lot. Maloney said he was, but there were special circumstances which he had better explain. Polita then asked if it was not true that Maloney had informed Mr. Bourget, owner of the motel, that the Collection was his, and also if he had made a deposition to that effect to an official of the Securiguard service. Maloney said this was the case, whereupon Polita asked if he, Maloney, had a city

permit to exhibit merchandise in a public place. Maloney explained that he was not exhibiting the Collection but merely guarding it pending its ultimate disposition, which had not yet been determined. Polita then said the way the Collection was set up in aisles, it certainly looked as though somebody was planning to exhibit it. He inquired as to the country of origin of the goods and asked by what right they had been imported into the United States. It was then that Maloney, knowing the extreme danger of telling his story to a policeman, nevertheless began, haltingly, to recount exactly what did happen, namely that he was a Canadian passing through Carmel, and that he had had a dream. And so on.

On completion of Maloney's account, Lieutenant Polita, masticating gum, stared out of the window for what seemed an unconscionably long time. Then said: "You say you woke up, went to this window here, looked out, and that this stuff you dreamed about is what's sitting in the parking lot there? Is that what you just said?"

Maloney agreed it was. Lieutenant Polita then asked: "Are you Catholic?"

"No."

"That's funny."

"What do you mean?"

"I mean this is a miracle, isn't it?"

At this juncture the second police officer looked up and uttered a loud laugh. Lieutenant Polita joined in. Still laughing, both men went toward the bedroom door, but as they were about to leave the room, Lieutenant Polita turned, unsmiling, to announce that Maloney's story was in no way to be believed, that his possession of the Collection laid him open to several

possible charges, that the police proposed to look into his record and the circumstances of his arrival in the United States, and that further proceedings could be taken in the matter. After the departure of the police officers, it became evident that they had also sown seeds of mistrust in those who harbored Maloney and the Collection. This became apparent almost at once when Bourget knocked on the bedroom door.

"When the photographer is through, I want that stuff removed from my lot. I want the place clear by morning, you understand?"

"But you accepted two days' rent."

"I'll give you a refund. I don't know what your business is, but I don't want any part of it. I've never had any trouble here."

"Mr. Bourget, I've done nothing wrong. On the contrary."

"You've got no per*mit*. That's what the officer said."

"What sort of permit?"

"How do I know what sort of per*mit?* You're in the antiques business, not me. You say you own this stuff, then you should know what sort of per*mit* you need."

Maloney told Bourget he would see what he could do. Bourget left. A few minutes later a man named John Lilley phoned from the motel lobby, saying he was from the Monterey television station and asking for an interview. He had, it seemed, heard from the local police of the Collection's existence. Maloney agreed to see Lilley, and as he stood in the motel bedroom, telling his story to the reporter, the following incident occurred. This description of it was later tape-recorded by the Vanderbilt University researchers:

"I remember when I talked to Lilley, it was about five

o'clock and still quite light. But I had a feeling that the sky was getting dark. At the same time I felt myself becoming sleepy, as I had earlier in the day. I went to the window and opened it, hoping the fresh air would revive me. Below me, moving in an aisle of the Collection, was a man with cameras and lighting equipment, the photographer, I supposed, from *The New York Times*. I saw him turn some floodlights on a stall containing a pianoforte, an equitone saxophone, and other musical instruments. The photographer approached the stall and, raising his camera, clicked the shutter. The objects he had photographed seemed to shimmer, fade for a moment, then reappear, not as they had been before but with a slight—I can't quite explain it—well, a slight difference in their texture. I remember that I called out: 'Wait! Stop!' and that Lilley, coming to my side, asked me what was wrong and I said: 'They're being spoiled.' I had no idea why, but I saw that the original bloom was no longer present on these particular instruments. It was as though, by being photographed, they had lost some of their natural freshness.

"At that moment a second man appeared behind the photographer, a large bald man who shouted to me: 'I'm Brewster from the *Times*. Are you Professor Maloney? What's wrong? Is something wrong?'

"I was unable to answer. I had invited these people to come here. I sensed that, while they were performing their job, their attitude was wholly skeptical toward my claims. If I now forbade them to photograph the Collection, how could I secure the record I needed in case it disappeared before the day was over? The slight fading, the difference in the objects before and after photography, was visible to me, but might not be to other

people. The truth is, I had got myself into an awkward situation and didn't know how to get out of it. The bald man, Brewster, was at least ten years older than I and was obviously accustomed to giving orders. He intimidated me. And, at that very moment, Lilley, standing by my side, asked permission to do a filmed television interview with me. I told myself I must not be overprotective of the Collection. Other people were now involved. In a way, the Collection seemed to be passing out of my hands."

It was true. From that point on, not only the Collection but he himself seemed to be passing into the control of others. Brewster and his photographer bustled in and out of the motel bedroom, as did lighting and sound men and other members of the local television crew. A makeup girl arrived to put tan coloring on his face. Lilley began to prepare a list of questions. In the midst of all this, Maloney began to feel hungry. "I think I'll run out and get a sandwich," he told Brewster. "I haven't eaten all day."

"No, better stay here. We might need you. We'll get some food sent in. Hey, Vaterman! Go get some food—pizza, chicken, beer, and whatever. Professor Maloney is hungry."

"Brewster, I am a reporter. I am not your servant."

"Are you working for us, or aren't you? Go get some food."

"Are you trying to insult me? Who the hell do you think you are?"

"Wait," Maloney said. "Why can't we just phone for some food?"

Brewster at once backed off. "Fine by me. Whatever you say, Professor."

Vaterman, his pale anger subsiding, came confidentially to whisper in Maloney's ear. "Thank you, Professor. I'll be delighted to phone. Just tell me what sort of food you wish. As for beer, perhaps I can ask my girlfriend to pick up a case. I would like very much for you to meet her. Will that be all right?"

"Of course."

Half an hour later, Bourget telephoned from the lobby. "Professor Maloney? Listen, I'm not running a restaurant here. What is this?"

"What is what?"

"Some girl looking for you. Beer delivery. And two delivery boys with a whole heap of food blocking up my front entrance. That entrance has got to be kept clear. That's the law."

"That will be my girlfriend," Vaterman told Maloney. "Let's go and get her, okay?"

Together they went out into the lobby.

Vaterman's girl was about twenty years old, tall and slender, with glossy auburn hair which fell to her shoulders. She wore a simple, long, white cotton dress and a red velvet cape. Her feet were shod in thong sandals.

"This is Professor Maloney, Mary Ann. Professor, this is my girlfriend, Mary Ann McKelvey."

Her eyes met Maloney's and at once she blushed. "Pleased to meet you," she murmured in a voice so low he barely heard it.

"Where do you want the stuff?" one of the delivery boys asked. "It's forty-one fifty with the side orders."

Vaterman took charge. "This way, please"—ushering the delivery boys toward Maloney's motel room. And, as

she did not move to follow, Maloney found himself alone with the girl. "You go ahead," she said in her half whisper. "I'll just wait here."

"Maybe you'd like to join us for supper? There seems to be plenty of food."

Again she colored and, avoiding his eye, seemed to search the ceiling for an answer. "Well, I guess not. I mean, I'd have to ask Fred."

"Let's go and see him then. He's in my room."

The shy have a power to transmit, like disease, their awkwardness of movement. Maloney at once became clumsy, maneuvering her across the lobby toward his motel room, where Lilley, the television reporter, ignoring her, pushed past her, his smile fixed on his subject. "If you're ready now, Professor? Perhaps we can do the interview before you eat?"

The television interview. Cameras pointing at him. The lights. The deferential yet inquisitorial tones of the interviewer. This moment, more than his dream, had the unreal, minatory quality of a dream. And, later, when the television crew had departed and supper had been eaten, companionably, with Brewster and his photographer and Vaterman and his girl, Maloney turned on the television set and, within minutes, was presented with his first sight of himself on a television screen. Not that self he thought he knew, but a shabbily dressed stranger, a person whose hands clenched and unclenched as he spoke, that same stranger he sometimes caught sight of when trying on a jacket in a triptych mirror in a clothing store, a person not to be trusted, now telling an absurd-sounding story until, mercifully, the camera cut away from him, leaving the disembodied voice to stammer on as it panned down from a nearby rooftop, roving among aisles and stalls,

34

inspecting a tiny part of that plethora which was the Collection.

"Hey, they shouldn't have done that," Vaterman said. "You never gave them permission to take any shots."

"Quiet!" Vaterman's girl's voice was suddenly loud. Everyone stared at her as, squirming, she seemed to fold herself inward in instant embarrassment. "I'm sorry—it's just—what Professor Maloney's saying is so interesting."

Maloney looked at her. She sat, hunched before the television set, her dress rucked up to reveal her elegant, coltish legs, as, mesmerized, she stared at the television screen. And suddenly it came to him. This girl believes in the Collection. As other people will believe in it. Unlike those ghost things you read about, this can be photographed. People will know it really happened.

Roughly half an hour after the local television news ended, cars began to appear on Bluff Road, moving in a clogged procession toward the Sea Winds Motel. A red chain of taillights winked on and off all the way down to the ocean and back up through a maze of connecting streets into the center of Carmel. Some drivers, abandoning their cars, moved on foot toward the parking lot, to stand, a frieze of faces, facing the security guards at the entrance, watching the photographer at work. In time, as the press of the crowd grew, a few adventurous teenagers managed to duck past the two security guards. The guards, running to pursue them, left the main entrance unattended. Within minutes the aisles, stalls, booths of the Collection were filled with a throng of curious sightseers.

Brewster phoned the police. The Salinas County Sheriff's office, on learning that the request for assistance came from *The New York Times,* at once promised full cooperation. Two patrol cars, followed by a crowd-

dispersal unit, arrived at full siren. Sheriff's deputies, equipped with bullhorns, entered the parking lot and evacuated the mobs of sightseers. Warnings were broadcast that souvenir hunters would be prosecuted. Within minutes, the lot had been emptied, apparently with no damage or loss to the many groupings of the Collection. Police barriers were then set up, sealing off the block containing the motel, and through traffic was rerouted by a detour. Shortly after eleven, the flow of sightseers having been diverted and the crowds dispersed, the sheriff's deputies left the scene. The photographer's floodlights were switched off. Coffee was served and Brewster announced that the job of photographing the Collection was complete.

"No, it's not. Not yet," Maloney heard himself say.

"What?"

"There are a number of concealed drawers, cupboards, and compartments which have things hidden in them. The Victorians had many secrets. For one thing, there is the Carrington Collection of Flagellatory Instruments and Literature, which is concealed behind a false wall in the Zollverein Indian Room. There is the Dodson-Hutter Collection of Pedophilic Photographs, concealed behind false panels in a sideboard carved in oak in the Renaissance style by Graham and Sidgwood of London. There are some holograph wills concealed in double-bottomed drawers. The Victorians were secret hoarders. There are at least two golden-sovereign collections which you have not yet uncovered. There is a silver-coin hoard. There is an artificial phallus concealed in a false compartment in the statue 'The Turkish Slave' by Henry Powers. There are a number of wonderful things like this, which you've missed."

Brewster, who hitherto had conducted his inquiries in

36

a polite, if skeptical, tone, now showed his first sign of irritation. "Why didn't you mention this before?"

"I didn't know about it before," Maloney said. "I just sensed it now, when you said the photography was finished."

Brewster sighed. "All right, Harry," he told the photographer. "You can wrap up now. We'll get those other shots in the morning."

"But that may be too late," Maloney said.

"What do you mean?"

"I mean, if I fall asleep tonight, maybe the Collection will go out of my mind and vanish."

For a long moment Brewster was silent. Then he signaled his photographer. "Okay, we'll do it tonight."

"But how will I find the hidden stuff?" the photographer asked.

"Professor Maloney will have to show us. Right, Professor?"

"Yes, fine."

At that moment Vaterman's girl whispered, "Fred, I'd better be going."

"I'll see you home," Vaterman said.

The girl, Mary Ann, stood, then, awkward, turned to Maloney. "It certainly was a great pleasure meeting you, sir."

"Please. My name is Tony."

She blushed and shook her head, as though this familiarity would be impossible, then said in her whisper, "I'd really like to, you know, to really see some of those wonderful things, sometime."

"Well, come back tomorrow. I haven't seen most of it myself."

"Oh, no, I couldn't disturb you."

"No bother."

The photographer, girding himself with cameras, interrupted. "Ready, Professor?"

"Right. Good night, ah—Mary Ann."

"Good night."

And so Maloney went with Brewster and the photographer down to the darkened aisles of the parking lot, going unerringly toward the secrets of the Collection, opening first a hidden back panel in an oaken cabinet by Grace of London to reveal the rare holograph will of a poor clergyman, bequeathing his four young daughters as an aid and comfort to the knight who paid for his living. From there he went to the hidden Papist codicil signed by Lord Craigbroke, which was concealed in a statue entitled H.R.H. the Prince of Wales as a Young Shepherd, a work by T. and A. Thornycroft. From this discovery he led the photographer to the grand center portion of a service of plate presented to the Earl of Ellenborough in India. Within the largest urn, he uncovered a hoard of one hundred golden sovereigns. From a massive tea service made of California gold by Ball Tompkins & Black, he took a treasure of five hundred silver crowns. Then, from a variety of false drawers, hidden panels, and double-door bookcases, he withdrew a dozen or more smaller hoards, purse after purse of sovereigns and half sovereigns, so well hidden by thrifty Victorians as insurance for a rainy day that they remained undiscovered after their owners' untimely deaths. But the first great shout of surprise came from the photographer when Maloney pressed a concealed button in the wooden nipple of a carved rosewood nymph which stood at the entrance to the Indian Room, a room in the manner of the Raj, designed by Sir Arthur Zollverein for a former viceroy. Slowly, a false wall rolled aside at the rear of the room, to reveal a

secret chamber within, an inner room some fifty feet long by eighteen feet wide. This was the Correction Chamber, designed by Charles Carrington, master of that Paris publishing house which dominated the field of English erotica at the turn of the century. There, in addition to a wall displaying various instruments of flagellation, were two stout wardrobes filled with choice items of bondage, a selection of whipping horses and torture racks, and some punishment costumes for females, featuring removable posterior panels. Further cries of surprise went up when Maloney pressed a concealed button in the nymph's left nipple. At that moment a second false wall fell away inside the inner, secret Correction Chamber, to reveal the entire collection from Carrington's Flagellation Desk, volume after volume lavishly illustrated, showing both youths and maidens engaged in scenes of Sadean torture and fornication. The photographer, loitering lasciviously over these drawings, at first showed interest in photographing a selection of plates, but Brewster, worried about the hour, vetoed this, ordering instead an overall shot simply showing a wall of books.

At one o'clock in the morning, while work was still in progress, Mr. Bourget came down into the lot and told Maloney that there was an urgent long-distance call for him from a Dr. Someone in Amsterdam, Holland. Maloney, on taking the call, found himself speaking to Dr. Johannes Fetema, the renowned Dutch clairvoyant and president of the International Society for Parakinesic Research. Dr. Fetema, who had heard a radio account announcing that Maloney had dreamed these objects into life, was, understandably, excited. After

introducing himself and giving his credentials, Dr. Fetema engaged Maloney in the following exchange.

"Professor Maloney, first may I ask you a personal question? Do you have a spirit, an animus? Are you a medium?"

"No, I'm not a medium. I don't believe in spiritualism."

"That doesn't matter. Has someone tried to get in touch with you? Some man or woman? A voice, perhaps?"

"No, nothing like that, sir. It was a dream."

"My animus indicates to me that you have met someone today who may be very important to you. The presence of this person may be connected with what has happened."

"No, sir, I don't think so."

"Yet, you had someone in mind just now? Someone you just met?"

"Yes, a girl. But I don't see the connection."

"Is she physically close? Say, in your building?"

"Well, she was here earlier."

"This is good. My animus indicates she may be of importance. Will you be seeing her again?"

"I don't know, sir. I think so."

"Excellent. Now, I have another question. Is it true that the objects you have materialized have disappeared from their former locations?"

"I don't know, for sure. Some of these things don't exist in other places. They are descriptions I read in books."

"Excellent! Congratulations."

"Sir, could I ask you a question?"

"Of course."

"What do you think will happen when I go back to sleep tonight? Will the Collection disappear?"

"No, you can sleep. Take my word for it."

"There's no danger, then, that the stuff will disappear?"

"There is always a danger. But my animus indicates to me in this instance that your achievement will not dematerialize overnight."

"Thank you, sir."

"Not at all. Get a good night's sleep. And again, my sincere congratulations."

When Maloney hung up, his former drowsiness had vanished. He felt elated. He at once went to Brewster to ask if the London office of *The New York Times* could find out if any items were missing from English collections.

"Why do you want to know?"

"Because, if nothing is missing, then I haven't merely moved the things from one place to another by some sort of telepathy. It will mean I've created a second set of originals."

"Okay, give me a list," Brewster said.

Maloney at once wrote out a short list, noting only large items which he had seen in the Victoria and Albert Museum. Brewster promised to cable an inquiry at once. Maloney then returned to the parking lot and helped uncover the last hidden items in the Collection. At 2 A.M., the photography having been completed, he left the parking lot and returned to his room. Alone for the first time since morning, he locked his door, went to the window, and raised the blind. Below him, graveyard

41

still in the harsh Pacific moonlight stood the stalls, aisles, and awnings of the Collection. A guard, walking down the central aisle, sent his flashlight circling, will-o'-the-wisp over the booths. Why had this happened? Was this the beginning of some new stage in human history, a time when objects from former eras would begin to materialize, piling up on people's front doorsteps?

Maloney did not believe in God. God was, like Santa Claus, a word his mother used. Nor did he believe in evil spirits, extrasensory perception, or creatures from another planet. Even now, looking out at the Collection, he did not for a moment entertain the notion that some mystical Presence had willed this to come to pass. Nor could he believe it was a hoax: the Collection was too astonishing, too valuable to be anyone's prank. In a way, as its possessor, he was already, potentially, a very rich man.

He pulled down the blind, went into the bathroom, and began to undress. Mirrored in the cold hygienic lights, his naked body seemed angular and ungainly, his face a Judas face, already trapped in damaging admissions. Looking at himself, recognizing that undependable other he had known all his life, he felt he would convince no one: historians, police, press, scientists—imagine the inquiries this face must now face: think of the hundreds of times it will look baffled, deceitful, stupid, when asked these unanswerable questions.

No. One dream was simply not enough. People would dismiss it as a freak accident, a flash in the pan. To make it stick, he would have to dream a second dream and deliver it into the world, real as the Collection. *Then* they would believe him.

He shivered suddenly in an unexpected, almost orgiastic spasm of excitement. *A new dream.* Naked, he

42

went back into the motel bedroom and lay on the bed. What if I've developed a talent for making my dreams come to life? Do I want to be rich? All right, supposing I dream of banknotes filling this room, stacks of hundred-dollar bills, all along that wall in groups of ten thousand. And thousand-dollar bills in groups of hundred thousands, stacked like ice cream bricks along that other wall. And cashier's checks for ten thousand dollars each, lying in a thick carpet across the floor.

He closed his eyes. Within moments, he felt himself nod toward sleep. On the screen of his dozing mind appeared the image of a small copper coin. On the back of the coin was imprinted a tiny bird. He recognized the coin as the British farthing. It was replaced by a half-penny, a penny, a threepenny bit, a sixpence, a shilling, a florin, a half crown, a half sovereign, and a golden guinea, all bearing the likeness of the old Queen. I am dreaming of a collection of Victorian coins—a part of the Great Victorian Collection.

He opened his eyes and sat up, disconsolate. It's just part of the old dream: it's not original. Think of something else. Lie down. Concentrate.

Women. If, in a dream, I could make a beautiful girl walk into this room and lie down here beside me? And then waken to find my dream come true? Eyes shut, he ran his hands over his stomach, caressing the insides of his thighs. I am naked. I will dream of her coming in, closing the door, taking off her dress and, naked, lovely, coming to me, lying on me, caressing me.

Again, he felt drowsy. The key turned in the lock of the motel-room door. A woman entered the room, a tall, long-necked, white-skinned woman, wearing elbow-length black evening gloves and a low-cut black evening gown. She advanced, gliding to the center of the room as

43

though she were being transported on a moving staircase, and now, standing before him, modestly averted her eyes from his frontal nudity. As she stood, immobile, he knew she was not flesh and blood. Familiar, yet false in her proportions, she was not a woman at all: she was a stylized portrait, a Victorian oil, "Portrait of Madame X" by John Singer Sargent.

As soon as he knew this, he awoke with a harsh cry, sitting up as though surprised in nightmare. *Maybe I can't dream any other dream?*

He shivered, but this time it was with tension. Although the night was warm, he reached down and drew the coverlet up over his naked limbs, even covering his face. He lay in this dark tent of his making, and after a moment, his fear subsiding, a drowsiness again touched his limbs and, slave to some Morphean command, he abandoned himself to sleep. And to the dream. And in the dream he rose from the bed, climbed out of the window, and walked again among the aisles of the Collection, examining with pleasure the contents of these stalls and stands—the paintings, the furniture, the manufactories, all those tangible, visible proofs of Victorian life on earth. In his dream, he patrolled his creation, awed at what he had wrought, watching over it, admiring it, guarding it. If it was not wholly original in concept, it was, nonetheless, his own. He had dreamed it into existence and now he dreamed that he guarded it. He was its owner and its custodian. He dreamed all night. And, in the morning, woke.

3

The sun shone. He got out of bed and ran to the window. The stalls, the awnings, the booths all stood. He heard a rush of murmurs, a stirring of feet as in the street beyond the police barrier the crowd sighted him. He looked on them in astonishment, and they on him with a mixture of excitement, curiosity, and disappointment. Saluting, a security guard in the aisle directly below his window called up, "Good morning, sir." Behind him, in the motel corridor, he heard a hurrying of feet, as though his awakening had just been announced. A moment later there was a knock. He unlocked his bedroom door.

It was Brewster. "How're you feeling?"

"Fine."

"I've got bad news for you. We've got an answer from London. Our office there has checked the Victoria and Albert Museum. None of the pieces you list are missing. Therefore, this stuff is fake."

"It's not."

"How can you still say that, Professor?"

"I don't know. I just know that there are now two sets of originals."

"The British don't agree with you. The London *Sunday Times* calls this a great American hoax. They've already commissioned a top Victorian expert and put him on a plane. He should be here later today."

"Good."

"You're not worried, then, Professor?"

"Why should I be? I've nothing to hide."

There was a second knock on the door. Maloney opened to the sight of Vaterman, hovering on the threshold, holding up, like a banner, the front page of *The Monterey Courier.* The entire page was given over to the story, with a photograph of Maloney and an overall view of the Collection. Maloney took the paper and began to read:

PROFESSOR CLAIMS HE "DREAMED UP" MYSTERIOUS

VICTORIANA COLLECTION FOUND IN CARMEL

By Fred X. Vaterman

A collection of Victorian objects worth, possibly, hundreds of thousands of dollars, including a scandalous collection of books and photographs of Victorian pornography and a sex torture chamber concealed behind hidden walls, has mysteriously appeared in a parking lot behind the Sea Winds Motel, Bluff Road, in Carmel-by-the-Sea. An avalanche of inquiries and world-wide interest yesterday followed announcement by Professor Anthony Maloney of McGill University, Montreal, Canada, on local Monterey station KCBC, that he . . .

46

Vaterman, interrupting, announced self-importantly, "It's just the story I wrote for my own paper, but already it has been picked up by all the wire services. It's gone out to newspapers all over the country."

"I only made page 6 in the *Times*," Brewster said. "Our editors are tough on miracles."

At the doorway, Bourget, the motel proprietor. "We held all calls until you woke, Professor. But I have one on the line now from a lady, says she's your mother. Says it's very urgent."

"I'll take it."

He sat on the bed, receiver in hand, watched by his new retinue.

"Tony, is that you?"

"Yes, Mother. How are you?"

"Oh, Tony, are you alone, can you talk?"

"Yes, go ahead."

"Well, look, what happened? What's going on out there?"

"You've seen the newspapers, haven't you? It's true. I had a dream and woke up and here it is."

"A dream? Oh, Tony! I'm your mother."

"But what can I tell you? The stuff is really out there."

"Tony, have you any idea the harm this has done you already? Which is the very reason I'm calling."

"What do you mean?"

"Well, one of the first people who was in touch with me this morning was Susan Morse. It seems Reggie hit the roof when he read the story in *The Gazette*. It identified you as a member of his department. And you know how strait-laced Reggie is."

"Don't worry about Reggie Morse. I have to call the

Dean, anyway. I'll need a short leave of absence to arrange things here."

"Dear, do you think that's wise? A leave of absence? I'd come home now, if I were you. Listen, on second thought, why don't I fly out today and we can travel back together. I could call Susan and say you've been sick and that I'm going out there to bring you home."

"Mother, do you hear me, you're *not* to do anything of the kind. I'll phone the Dean. Everything's going to be all right."

"Oh, Tony!" His mother seemed close to tears.

"Mother, please. Calm down."

"All right, I'm calm. But you be very careful what you say to the Dean, won't you? Promise me?"

"I promise."

Maloney hung up and at once put in a call to Dean A. D. MacDonald at the McGill University Department of History. The important thing was to get his word in ahead of Reggie Morse. The Dean's secretary said the Dean was at his Monday Luncheon Club and would return all calls later in the day. As things turned out, he did not call back for two days.

Thus, the morning began ominously. A little later, Brewster came back from a telephone conference with his New York superiors. "Well," he said. "The story seems to be picking up interest. We've decided to send out our own expert to check on your collection. He should be here this afternoon."

"Who is he?"

Brewster consulted his notebook. "A Professor Clews."

"H. F. Clews of Yale. Who's the British expert, do you know?"

48

Brewster turned a page. "Sir Alfred Mannings. That ring a bell?"

"It certainly does."

"That's the line-up then. Good luck."

At noon, Lieutenant Polita of the Salinas County Sheriff's office arrived at the motel in company with a Mr. Rank, who produced his badge and introduced himself as an agent of the Federal Bureau of Investigation. Maloney was then asked to make and sign two depositions, which were witnessed by Bourget. Mr. Rank asked several questions as to Maloney's family background, marital status, trips abroad, former positions, and earlier visits to the United States. Lieutenant Polita, after telling Maloney he, Polita, would, from now on, be working full time on this investigation, informed him that the bona fides of the Collection would be looked into by both state and federal agencies. He advised Maloney not to leave town and scheduled a further session for the following morning at 11 A.M.

As soon as the police officers had left, Maloney went out into the motel lounge, where he found Vaterman and Vaterman's girl sitting, sipping Cokes in the front parlor. At once he remembered the clairvoyant's remark. Could this girl really have something to do with his dream?

"Hello, Tony," Vaterman said, familiarly. The girl blushed. Maloney went to her and stood, staring at her. "Did you come to see the Collection?" he asked.

"Well, yes, but please, I don't want to disturb you. If I can just sort of look around on my own?"

"No, no. I mean, I enjoy exploring it myself. It's still

49

pretty new to me, you know. Let's go and look at it together."

"What I want to see," Vaterman said, "is that hot stuff you turned up last night after I'd gone home."

Maloney looked at the girl, who at once avoided his gaze. "Well," he said. "Actually it's pretty disgusting."

"Don't kid yourself," Vaterman said. "It will be the most popular part of the Collection."

They went out. Maloney noticed that the girl's shyness seemed to disappear completely while she was viewing the exhibits. Excited, almost childlike, attendant on every word he spoke, she followed him, entranced, as he started a tour of the main aisle. But Vaterman quickly became bored with such treasures as the Ross telescope and the Osler fountain. "What about the hot parts?" he began. "Mary Ann doesn't mind, do you?"

"No, Fred, no. But it's *all* interesting."

"Okay, but let's see the part I want to see. Okay?"

She nodded, her rich auburn hair falling forward, masking her features. "Sure," she said. "But it's up to Tony."

"Okay then," Maloney said. Suddenly he felt excited. "It's this way, just past that music-hall exhibit."

In the Indian Room, designed for the Marquess of Longview by Sir Arthur Zollverein, the lighting was a mélange of subtle yellows, emanating from lamp globes of frosted glass, shaped like half-opened water lilies. Maloney approached the rosewood statue of the wood nymph and touched the concealed button which was her right nipple. Slowly the false wall rolled back, revealing the Correction Chamber. "Oh, my!" said Mary Ann. Timid as a sacrificial vestal in her long white dress, she stepped uncertainly into the center of Carrington's evil dream. As she walked by the flogging horses and punish-

ment racks and paused before a wall hung with every kind of spanking equipment, including hairbrushes, worn slippers, leather belts, birches, rattan canes, thong whips, cat-o'-nine-tails, and an enormous bull's pizzle, Maloney pressed the wood nymph's left nipple. The back wall of the inner chamber creakingly slid back to show the bookshelves of Sadean literature. Vaterman, grinning, pulled down one of the larger illustrated volumes, opened it, and handed it to Mary Ann. Her glossy auburn hair hid her face as she bent over the illustration. There was a swift intake of breath as she stared at a beautiful girl, her knickers down about her ankles, being flogged on the buttocks by a schoolmaster in Holy Orders. A huge member protruded menacingly from the cleric's unbuttoned trousers. Shamed (what will she think of me for dreaming up stuff like that?), Maloney hurried to take the book out of her hands. But failed: she turned away from him, abruptly, as though they were children engaged in some game. "Wait! I haven't seen it yet."

"It's pretty awful stuff."

"No. Look at this." She held up a double-page illustration showing a curious combination: a gentleman in riding breeches sodomizing his housemaid as she horsed a younger girl, whose posteriors he flogged with a thin cane. "Why is he beating her?" she asked.

"Hey!" Vaterman held up a folio of tribadic scourgings. "There's some great stuff here. You know, I should do a follow-up story on this side of your Collection."

At that moment, one of the Securiguard attendants entered the Indian Room. "Professor Maloney, Mr. Brewster says to tell you that one of the experts is here."

"I'd better close up, then," Maloney said to Mary Ann.

"No, you go ahead," Vaterman said. "I'll do it. It's these little buttons on the nipples, right?"

"Yes. Right. Are you sure you want to stay here?"

"Yes. We're having fun. You don't mind, do you?"

"No," he said, and unwillingly withdrew. His last vision of the Indian Room was the sight of their heads together, her auburn mane, Vaterman's porcine, whitish locks bent over a truly erotic first edition of *Une Société de Flagellantes,* Charles Carrington, Paris, with 31 illustrations by Martin Van Maele and A. Lambrecht.

Professor H. F. Clews, who waited in the parlor, was tall, with a port-wine nose and protuberant eyes arrested permanently in a glaucous stare. He was known to Maloney, and, indeed, to all historians of the period, as the author of the *Tractatus of Victorian Chroniclers* and also of many learned monographs.

From the first, Maloney feared him: sensed his implacable enmity. The inquisition began in cold unease and lasted more than an hour. Then, having declined Maloney's offer to act as guide, Professor Clews set off, unaccompanied, to the parking lot. His examination was thorough. At dusk, he sent word that he would need a flashlight. Floodlamps were also set up in the main aisles. The painstaking examination continued.

Sir Alfred Mannings, the second expert, arrived shortly after seven, declaring himself exhausted by his long flight from London. He at first stated that he would go directly to his room, but on learning that Professor Clews was examining the Collection, at once called for a flashlight and went down into the parking lot. He did not bother to interview Maloney. Soon, his flashlight began crisscrossing that of Professor Clews.

The experts did not speak to each other beyond a polite "Good evening." Reporters began to assemble at the entrance to the lot. There was a sense of tension, almost of crisis. As Vaterman and his girl drifted through the lobby, Maloney overheard their whispered conversation.

"Why are they taking so long, Fred?"

"Because they think the stuff is phony."

"But how could they? It's so beautiful."

"Oh, come on! It's just a lot of stuff."

"It's not. It's terrific."

"How do you know? What makes you an expert?" Vaterman said, but at that moment the girl, seeing Maloney in the lobby, nudged Vaterman, warning him to silence. Both smiled falsely as Maloney passed by.

At 10 P.M., Professor Clews came up from the lot. As his professional opinion had been commissioned by *The New York Times,* he first asked for a private meeting with Brewster, promising that he would hold a press conference afterward.

"May I join you?" Maloney asked Brewster.

Professor Clews stared, his glaucous eye forbidding. "Unethical," he said to Brewster.

And so, humiliated, Maloney was forced to wait with the reporters while Brewster and the expert closeted themselves in Brewster's room.

Later, Brewster wrote for his superiors a report on this secret meeting. From the outset, Professor Clews cast doubt on Maloney's qualifications as a historian. "While this young man may have received a doctorate from a *Canadian* university," Professor Clews told Brewster, "there is absolutely no reason to believe that

53

his knowledge of Victoriana is that of an expert. There is, to my mind, something wholly untrustworthy about this young person. Perhaps he is insane. I am not qualified to judge. But, certainly, his claim that he 'dreamed up' this collection is not worthy of serious comment, don't you agree?"

"But what about the Collection itself?" Brewster asked.

"Very skillful fakes. In addition to items from British public collections, it contains what seem to be skillful imitations from private collections, not known to me personally."

"Maloney claims that many of these items have only been written about and that they do not exist in any known collection in their present form. In other words, that they are his own original creations, based on his research."

"I know what he claims," Professor Clews said. "But I would suspect the truth is rather more prosaic. In my view, these copies were created in what is, almost certainly, a fraudulent attempt to lure collectors to purchase them at very inflated prices. Nowadays, as you may know, there is a considerable collecting boom in items of Victoriana."

"So you believe that all these things are fakes?"

"Well, no. Possibly the coin collections and the pinchbeck jewelry collection are genuine. Hard to tell with that sort of thing. But in the majority of cases the things you see out there are copies of well-known originals which I know are stored elsewhere. Ergo, these copies here are just that. Copies. Fakes."

"All right. But don't you think a clever crook would think up a more plausible story?" Brewster asked. "I

54

mean, no one in his right mind could hope to get away with saying he dreamed this stuff up. I've been wondering who's behind Maloney. He doesn't strike me as very smart."

Professor Clews made a small rictus, impersonating a smile. "As a historian, let me comment that such conjecture is dangerous. I can only say that were I you, and were I representing a national newspaper, I would exercise great caution to avoid giving credence to a hoax, exposure of which will certainly discredit you and your publication."

"So you're sure it will be exposed as a hoax?"

"Indubitably."

"Okay. But, as we hired you for an opinion, I'd be obliged if you'd say nothing to the other newspapermen until I have time to check this out with my office in New York."

"Mr. Brewster, my contract does not specify that I must keep silent. Silence, in this case, would imply tacit approval of a probable fraud. I am afraid, if asked, I must tell the truth as I see it. After all, my critical reputation is at stake."

"All right," Brewster said. "In that case, let's get it over with."

But when Brewster and Professor Clews went down to the motel parlor, a press conference was already in progress. The reporters, together with Mary Ann and Maloney, were listening to Sir Alfred Mannings, who delivered himself of the following opinions.

"First of all, I have not interviewed Professor Maloney and, thus, cannot make a judgment on the truth or otherwise of his assertion that these items are supernatural in origin. Alas, I am not qualified to deal

with such metaphysical matters. What I am qualified to discuss—and no one is better qualified, may I add—is the authenticity and origins of many items which you can see outside there in that car park. I am Director General of British Imperial Collections with authority over the museums in which a great many of the originals of these items are on exhibit."

A reporter from Reuters interrupted: "You said 'originals,' Sir Alfred. Does that mean you believe these items here to be copies?"

"Let me try to be more precise," Sir Alfred replied. "The extraordinary fact is that every object of which I have first-hand knowledge is here reproduced in a form indistinguishable from its original. Not only that, many items known to me only through book illustrations and other descriptions are here reproduced just as they must once have existed. It is a truly astonishing feat of copying."

Maloney, face flushed, heard himself speak up in protest. "Why do you say they are copies, if you admit there is no original in existence?"

"You would seem to have a point there, young man," Sir Alfred said. "But let's think about it, shall we? Perhaps there is no original in existence. Yet you claim that you 'dreamed' these objects up after reading about them in books, and so on. Now, if you 'dream up' something which you have already read about, I hardly think you can claim it as an original creation."

"Then, in your opinion, Sir Alfred, this collection is *not* original?" the Reuters reporter asked.

Sir Alfred pursed his lips. "No, I do *not* think they are fakes. I believe they are neither original nor fake. Let me give you an example. Tonight, examining these

familiar and well-loved British artifacts twelve thousand miles from their true home, I must confess I felt moved to indignation. To see these wonderful treasures laid out in flea-market fashion in an American car park! One's blood boils. And then I came on an object particularly dear to me, because I was its original discoverer. I refer to the Nouds Hop Pickers Tea Urn, which I turned up many years ago, on Colonel Addison's estate near Sittingbourne in Kent. Gentlemen, I dug the original urn out of the earth. I know its lineaments as I know those of my own face. Yet this tea urn here in Carmel not only resembles the original Nouds urn, it is *indistinguishable* from the original. It was as though today I became the first man in the world to look on something which has never been seen before: a unique object which has, mysteriously, become a duality."

"Then it's *not* a fake?" the Reuters man persisted. "You're saying it's sort of a mysterious re-creation, or something?"

"I am not saying it's *not* a fake," Sir Alfred warned. "Nor am I saying it's original. I am saying it may be something which has not been categorized before, an act of homage to a period, perhaps. I'm afraid I'll have to think about it. I simply say we mustn't be too hasty in assigning it a category."

Professor H. F. Clews, who had entered the room with Brewster and had listened to most of Sir Alfred's remarks, now interrupted testily. "A fake is a fake."

"So you believe they are simple fakes, do you, Professor Clews?"

"Surely you are not claiming them as originals, Sir Alfred?"

57

"No, of course not."

"All right, then. If they are not originals, what is your opinion as to their origin?"

"I have no opinion on that," said Sir Alfred. "Because I don't know where they came from. Do you?"

"Well," said Professor Clews. "I don't for one moment believe they're the result of someone's dream. Do you?"

"Of course not."

"Excuse me, gentlemen," said the Reuters reporter. "Do I take it that both of you reject Professor Maloney's explanation?"

At this point the two experts exchanged glances; then, as though performing some prearranged vaudeville routine, they raised their eyebrows, shrugged, and nodded their heads affirmatively.

Maloney felt his face grow red.

"Well, gentlemen, it's quite late and I've had a very exhausting journey. Good night." Sir Alfred Mannings went toward the door.

"Good night, gentlemen," said Professor Clews, joining his colleague in the walk out. The reporters, including Vaterman, at once rushed for the telephones, leaving Maloney alone in the room with Vaterman's girl, who fidgeted for a moment, then came up to him, her large eyes serious, her manner that of a child preparing a recitation.

"I just want to tell you," she said, "that I think that was awful—just stupid. All that talk about fakes and originals—I mean, they're missing the point. The point is, you dreamed up this stuff and made it all come to life out there. That's got to be sort of genius—right?"

Flushing, a weal of redness going from her cheek to her long elegant neck, she turned and hurried out of the

room. He stared after her, moved—*sort of genius*—God bless her! But his anger, heavy and painful, remained as he went to his bedroom. All his life he had wanted to do something out of the ordinary. And now the subject he had studied, the objects he had seen and read about and remembered had suddenly escaped from his subconscious mind and become *real,* here in Carmel. Yet nobody seemed to understand just what had happened. All people talked about was whether these miraculous objects were originals or not. As if anything could be more original than one's dream come true!

And so, weary, worried, angry, Maloney fell asleep on that second night of the Collection's existence. And dreamed. And in the dream, rose from the bed, climbed out of the window, and walked again among the aisles of his Collection, looking with wonderment at the stalls, the stands, the paintings, the books, the furniture, the jewels, the manufactories, all those tangible, visible proofs of Victorian life on earth. In his dream he patrolled his creation, lovingly lingering over its particulars—a Collection unsurpassed by any other assemblage of its kind. He had dreamed it into existence and now he dreamed that he guarded it against all enemies in a world which did not yet realize its true worth. He was its creator and would become its defender. Again he dreamed all night. And, in the morning, woke.

4

"Tony, may I see you, please?"

"Sure, Fred, come on in. Where's Mary Ann? Did she come out with you this morning?"

"No, she's at her own place." Warily, Vaterman sat on Maloney's bed and unfolded a newspaper. "I wanted to explain this story to you. I didn't want you to feel angry at me personally."

Maloney took the newspaper. It was *The Monterey Courier*. On the right-hand side of the front page was a three-column headline.

BRITISH, AMERICAN EXPERTS CONCUR:
CARMEL ''DREAM'' COLLECTION IS
FAKE
*Yale professor hints at scheme to
defraud would-be collectors*

There was no need to read the story.

"I want you to know I didn't write that," Vaterman

said. "I sent in a more favorable version and Yorkin, my editor, had it rewritten. It's not my fault."

"That's all right, Fred."

"And now Yorkin has turned the follow-up story over to the police desk. He wants me to go back to my regular beat. It's awful. I mean, this is the most important story that ever happened in this town and they're trying to ruin it."

Angry, Vaterman tossed the newspaper aside and stood up, his whitish locks forming an aureole around his impassioned face. "Not only that," he said. "These stories are ruining *you*. You've got to clear yourself. You should put out a press release, stating your position. Better—you should call a press conference."

"What about? What can I say?"

"Wait, wait," Vaterman said excitedly. "I've just had a great idea. Why don't we get Mary Ann to come to work as your secretary? I could write your press releases and she could type them. We could really help you."

"But I couldn't ask you to do that."

"Why not? Listen, it would be good for me too. You see, with Mary Ann working right here in the motel, I could keep up with every development of the story."

"I thought you said you'd been taken off the story?"

"But that's it!" Vaterman, agitated, went to the window and pointed dramatically to the aisles and awnings of the Collection. "This is *my* story. I've got to stay with it."

"Look, Fred, there's another point. I can't afford to pay you."

"Don't worry about that. The way we feel, Tony, it will be an honor to help you. Besides, Mary Ann doesn't have any job right now and, between ourselves, the kid is bored sitting at home all day. Look—don't you want

to clear your name? Are you going to let these people call you a liar?"

"All right. Well, in that case, thanks. Thanks very much."

"Good. I'll tell Mary Ann. I think she should come over here at once."

"Are you sure she'll want to do it?"

"Of course, I'm sure," Vaterman said. "She wants to help me. And besides she's very excited by this Collection. She talks about nothing else."

"Well, I'll have to make some salary arrangement with her. Maybe I could sell off some item from the Collection."

"Don't sell a thing!" Vaterman said, buttoning up his safari jacket Mao-style, and turning, determined, in the direction of the door. "Just you leave it to us."

On that same afternoon a small hairy man arrived in Carmel by private plane and was brought in at once by Bourget in direct contravention of Maloney's instructions about visitors. "Professor, this is a gentleman who has arrived to see you. It's very important, I took the liberty."

Money had changed hands. Bourget backed out of the room.

"Professor Maloney, my name is Hickman, which may not mean anything to you. The firm of which I happen to be president is Management Incorporated, which you may have heard of."

"Mr. Hickman, this is my secretary, Miss McKelvey. She handles all appointments."

"How are you, dear. Professor, I know how important

your time is. I apologize for bursting in like this. But I felt this matter was important enough for me to make a special trip from New York. So if you will give me a minute? Just one minute?"

"All right. But we have a television interview at four, isn't that so, Mary Ann?"

"Yes, Tony."

Hickman made a small throat-clearing sound. "Thank you. First, let me say that in all my years in this business I've never seen anything so completely mismanaged as your discovery. Why, the way the media has treated you is a crime!"

"What is your business, exactly, Mr. Hickman?"

"Professor, I'll bet people are asking you who represents you?"

"No. Not exactly."

"Well, they will. And let me explain. Management Incorporated is not only an agent, it is a combination of lawyer, business manager, and personal friend. Do you realize the harm already done this collection of yours by allowing the *Times* to send in those experts without proper briefing? *We* would not have handled it that way. We would, first of all, have hired our own experts as a backup. We would have orchestrated the news of each step in this story for maximum effect. In the first place, I hear that the Collection contains one of the world's most fabulous lodes of erotica. Do you realize the audience potential in a discovery of that sort?"

"No, I suppose I don't. The dream aspect, I believe, is by far the most important one."

"Of course, of course. Professor, let me ask you another question. What do you think of the idea of moving this Collection to a more suitable location?"

63

"I'm afraid that would be very difficult."

"Why? I believe you know Dr. Johannes Fetema, the Amsterdam clairvoyant?"

"Well, we spoke on the telephone."

"Professor, before leaving New York I took the liberty of consulting Dr. Fetema, also by telephone. He gave it as his opinion that now that the items have fully materialized here, the Collection will not be damaged in the slightest by its transit to a new location."

Toy engine. Japanese fake. "He's wrong. It mustn't be moved."

"Is that a creative decision?"

"Yes."

"Very well. Will you let me get back to Dr. Fetema with a further question? I'll only be a few minutes."

"Tony, it's nearly four," Mary Ann warned.

"Your interview. Fine, go ahead. I'll contact you when you're through with your taping."

Maloney and Mary Ann then went across the corridor, where a television mobile unit had been set up. Half an hour later, when they emerged from the interview, Hickman was waiting in the corridor, a triumphant smile on his face. "Suggestion. What if you leave the Collection here in Carmel, but you yourself travel and lecture on it? Dr. Fetema thinks that would be possible. And I can set up a truly substantial set of bookings, if we move now, while this story is hot, so to speak. You could make one hundred thousand dollars in six weeks."

"One hundred thousand dollars?"

"That is correct, yes."

"And Dr. Fetema thinks the Collection won't disappear if I go away and leave it, under guard, here in Carmel?"

"That is his judgment, yes."

Maloney turned to Mary Ann. "You know, that means I could go back to Montreal. I could get my old job back."

"Why would you do that?" Hickman said. "There are thousands of history professors. But, as the creator of this Collection, you're unique."

"Look, I trained all my life to be a history professor."

"That's no longer the point, if you don't mind my saying so. The point is, did you or did you not dream up this Collection. Your credibility is the issue, don't you realize that?"

"He's right," Mary Ann whispered.

"Of course I'm right," Hickman said. "And when I suggest a lecture tour to put your point of view across, I assume you'll want to take your own people along. Like your secretary. Remember, it will be first class for you and your party all the way."

"Well, I don't know. I'd have to think about it."

"All right, why don't you do that. Tell you what. I have to go into Monterey for an hour. I'll come back and check with you before I leave for New York. All right?" Hickman produced, like a tip, a sudden, broad smile. He turned and went out of the front door. A Lincoln Continental waited. He waved to them as he got in.

Maloney and Mary Ann went back to the motel room. "Tell me," he said, watching her for reaction. "Would you like to go on a lecture tour?"

"Oh, gosh, I don't know. I'd have to ask Fred. But I do think you should get all the publicity you can."

"It's all very well for Dr. Fetema to say the Collection won't disappear if I go away from here. But what if he's wrong?"

She looked at him, her large, luminous eyes clouded with sudden fear. "Do you mean, if you leave, it might vanish, or something?"

"It might."

"Then you'd better not risk it." She went to the window and looked out. "It's—it's just the most perfect thing. It would be terrible if you lost it."

"Tell you what. Why don't I try an experiment, a sort of trial run?"

She turned from the window, her face questioning.

"I mean, I could get in the car and drive, say, twenty miles down the coast. You'd stay here and watch the Collection. I could phone back and check with you to see if it's still all right. Is Fred around?"

"Yes, he just came in. He's writing a press release in the parlor."

"All right. Let's tell him our plan."

"Well . . ." she murmured and hung her head.

"What's the matter?"

"Couldn't I come with you? We could leave Fred to watch the Collection."

"Why do you want to come with me?"

"I don't know. I just would like to come, that's all." -

"All right," Maloney said. "Let's go tell Fred."

Mary Ann wore a blue silk shawl over her long white dress. The sun shone as their car moved past the sightseers outside the parking lot, turning south in the direction of Big Sur. Maloney drove in silence, and as they passed the rich villas on the outskirts of Carmel and came to a bare, bleak vista of cliffs and cold turbulent ocean, he was filled with a panicky sensation, like the one he experienced in an airplane when he heard a

strange noise, the lowering of the undercarriage or the changing tempo of an engine. Within moments he had slowed to a pace so dilatory that other drivers began to sound their horns and move past, giving him angry looks.

"What's wrong, Tony?"

"Supposing it disappears?"

"It won't. And, like you said, you have to find out sometime."

"That's true. Yes, that's true."

"Would you like me to drive?"

"No."

"Then I think you could go a little faster. We're holding up traffic."

"Maybe we should stop and phone?"

"But, Tony, we've only gone eight miles."

He accelerated slightly and, as he did, felt her move closer to him on the car seat, her body from shoulder to long, elegant thigh reassuring him by the most subtle of contacts. Her voice, that increasingly familiar, diffident whisper, repeated, "It won't disappear. It *won't*."

He felt calmed. He began to drive faster. I've been under a constant strain, he told himself. I've needed someone to talk to. He felt grateful to her. He was glad she had come with him.

"Tell me?" he said, glancing at her. "Are you and Fred sort of engaged?"

Abruptly, she shook her head, her mane of auburn falling over her features. She moved still closer, peered at the odometer, then delicately moved away. "We've done just about twenty miles. There's a phone booth up there. You could pull in past that Mobil sign."

Obedient, he turned the car off the road, left the engine running, and entered the phone booth. Unease

caught him again as he began to dial. And Vaterman's voice, answering, confirmed it.

"Thank God you called, Tony. I think you'd better come back at once."

"What happened?"

"Well, about ten minutes after you left, it began to rain. Heavy rain. Mr. Bourget says he's never seen rain like it at this time of year. Many items are threatened with water damage."

"I'll come at once."

"We're covering up stuff with plastic drop sheets. I think we've saved most of it. But I'd hurry, if I were you."

Maloney ran back to the car.

"What happened, Tony?"

"Let's go."

He drove out of the gas station. She huddled close to him, shivering. "What *happened?*" she whispered.

"It's raining on the Collection."

"But it can't be. Look, you can see Carmel across the bay. The sun is shining."

"Fred says it's raining."

He felt her tremble. "It's my fault," she whispered. "I never should have let you do this."

They drove on. He leaned forward, staring at the wet ribbon of road ahead. "Look, it *has* been raining. Do you realize what this means? If I can make it rain just by driving out of Carmel, people are going to have to believe me."

"That's right." She seemed cheered. She touched his arm, her fingers tightening on his wrist. "Of course, they'll believe you. This Collection is going to be very, very important. And I want to be part of it."

68

He looked at her. What did she mean? But, suddenly, he was himself too shy to ask.

Vaterman waited for them in the street outside the motel. "Do you want to see the damage? And, listen, can I file a story on this rain development?"

"Yes, all right."

Maloney and Mary Ann went down the central aisle. The damage seemed minor. Plastic drop sheets were draped everywhere, giving the Collection the look of a shut-up market. As they turned into one of the side aisles, Hickman came bustling up behind them.

"Hi. How do you like the drop sheets? I rushed them over here for you. Bought out the entire stock in Carmel."

"Thank you."

"I'm here to help. By the way, have you made any decision on representation?"

"Yes, I suppose I'm interested."

"Good," Hickman said briskly. "Then let's you and I have a word in private. Let's go sit in your car. That way, nobody will disturb us."

Hickman smiled at Mary Ann. "See you later, dear."

In the car, Hickman consulted his wristwatch, which was set in a twenty-dollar gold piece. "I've got to get back to New York tonight. So, let me outline, briefly, what Management Incorporated can do for you. First of all, I take it the lecture tour is out?"

"For the moment. Unfortunately."

"In that case, Carmel becomes more important, as the site of presentation, so to speak."

"Look, I don't want the Collection turned into some sort of Disneyland."

"Absolutely. I entirely agree. The first thing is for me to have a meeting with my people in New York. Then we'll go out and talk to some money and as soon as we can line up a suitable funding proposal we'll get back to you and make you an offer which will take care of the guards and the other expenses, including salaries for your staff. In the meantime, we'll make sure that you and this story are promoted in the proper manner. Oh, apropos of that, Tony—mind if I call you Tony?"

"Not at all."

"This young fellow Wasserman says he's your director of publicity. He's got to be kidding, right?"

"No. I appointed him."

"Nothing in writing?"

"I gave him my word. I can't go back on it."

"Well, we'll work something out. You just worry about the creative end, Tony. By the way, may I ask if you have another dream in the works?"

"No, not yet."

"May I say something which might be out of line?"

"Of course."

"Well, this Collection is terrific, but apart from the erotic stuff, the kinky room with the whips and the brothel parlor and so on, most of it's a bit over the heads of the general public. I keep thinking, what if you could have another dream, a different dream?"

"I've thought of that, too. But perhaps a person can only dream the sort of thing he knows. And what I know is Victoriana."

"How can anyone tell what he's capable of until he gives it a try?" Hickman said. "Don't underestimate your potential. There are many exciting dreams you could dream."

"Like what, Mr. Hickman?"

"Call me Bernard, okay? Well, the first thing that comes to mind is how interesting it would be if your next dream had people in it. Imagine if you could materialize real people. That would be a major breakthrough."

"I should say it would. I would be known as God."

"Ha, ha. I must tell that to my associates. Well, I have a plane waiting. I think the best thing for me to do now is talk to the money and get back to you. And in the meantime we're going to get *our* side of this story before the public. You can expect to see our experts here tomorrow. And they'll be good ones."

"When will I hear from you about the funding?"

Hickman got out of the car. "We'll be in touch. Coming back to the motel now?"

"No. I think I'll just sit here a while."

"Well, pleasant dreams, Tony. See you soon."

And walked away, Bernard Byron Hickman, short and hairy, his expensive navy-blue blazer flung over his right shoulder like a tournament cape, opening to reveal a lining of rich crimson silk. Beyond, in the parking lot, a security guard placed stones on the loose edges of one of the plastic drop sheets which flapped in the wind with a sound like distant gunfire. Alone in the car, Maloney stared out at Bluff Road, where sightseers filed by in constant procession, peering in at the Collection as though it were a palace where, at any moment, Royalty might appear among the shrouded stalls. And there, in the middle of the road, was the madman he had seen this morning: a tall unkempt figure, barefoot, wearing a greasy black suit jacket and stained white duck trousers, holding aloft a hand-lettered sign which read:

71

As the madman, lips moving in a silent babble, walked purposefully along the crown of the road, a cab almost ran him down. The cab, veering sharply, drove in at the motel entrance, was signaled down by the highway patrolman on duty, and after examination of some document, was allowed to enter the motel grounds. When it stopped outside the front door, a woman got out and began to fuss with her handbag in a way which Maloney found instantly familiar. His mother. His mother, who, as soon as she had paid the driver, turned to stare distrustfully at the shrouded stalls of the Collection; she, who had created him, peering at these things which he had created. His mother and the Collection. Even and odd. True and false.

And in that moment, staring at his mother, Maloney thought of his dead father, his father whom he now remembered not as a person but as a figure in a photograph. His father, an amateur photographer, had rarely been photographed: he had insisted in taking all the family snapshots himself. In that one remaining picture, he stood with a group of fellow editors and reporters in the city room of the *Toronto Picture Sun*, shirtsleeved, a Leica around his neck, celebrating some long-ago circulation triumph by drinking rye whiskey out of a paper cup. His father, who had spent his life arranging newspaper layouts, lived on only in one fading group portrait. As the Collection, were it now to disappear, might continue to exist only as a set of photographs taken for *The New York Times*.

Maloney's mother, bending down, picked up her bag and went into the motel. Predictably, in less than five minutes, Bourget and Mary Ann were out, hunting him among the shrouded stalls. He waited in his car, until Mary Ann came close.

"Hey."

"Oh, there you are. Your mother's here."

He got out of the car. "I know."

"You don't look pleased."

"Would you be?"

"My mother's dead," she whispered. "I only have a father."

Together they went in at the front entrance of the motel. The ground floor, including the lobby, was the original frame house around which the Sea Winds Motel had grown. On their left was a lifeless parlor, its cretonne-covered armchairs, unused fireplace, and maple side table with green silk runner, artificial as a furnished room in a folk museum, a relic of that private life the Bourgets had permanently forsaken the day they nailed the shields of credit cards on what had been the front door of their home. In these drear surroundings, fretting and pale, Maloney's mother waited.

"Hello, Mother. So you came after all."

His mother smiled nervously, like a child expecting to be rebuked.

"This is Mary Ann McKelvey, my temporary assistant."

"Yes, we've met."

"Maybe you'd like some coffee, Mrs. Maloney?"

"No, thank you. If I could just have a few minutes alone with my son?"

"Of course." Squirming, embarrassed, Mary Ann fled the room.

"*Cherchez la fille,*" Maloney's mother said.

"Don't be ridiculous, Mother. That was very rude."

"Was it?"

"You know it was. Now why did you come here, when I told you not to?"

"Well, for one thing, I never heard from you again. And, for another, an hour after I called you I found out that Reggie Morse is definitely planning to get rid of you. Dear, listen to me. You must come home at once."

"What do you mean, 'get rid of' me? That's crazy."

"It's not crazy. They *are* trying to get rid of you. Susan says unless you're back at your classes by the beginning of the week, the Dean has agreed to look around for someone to replace you."

"To *replace* me?" he said. He walked across the parlor and sat on a cretonne-covered armchair, staring at the flower pattern in the rug, his mind moving gingerly around what it had just been told. He was twenty-nine years old. He had been a student until he was twenty-six. He had been lucky to find a university appointment in his home town. Very lucky. He had often said it himself, had had it said to him by former classmates, now exiled to academic Siberias in western Canada and the United States. To be a professor was to be respected, even if the money wasn't big. There were long vacations, there was a chance to do your own writing, there was advancement and, eventually, tenure. This rubble of facts, often chewed over in his mind as a hedge against dissatisfaction with present achievements and future prospects, now regurgitated with strange new intensity. Unless he was back in his classroom by next

week, he would be fired. His career would be ruined: he would not find another university post.

"Tony, can I say something? What if you were to come out now and tell them this is a practical joke? Tell them you made a bet with a friend in Montreal. Say you bet him that people would believe this story—now don't interrupt, please listen! If you own up now, it might just pass off as a sort of joke."

"Own up to what, Mother? Where do you think this stuff came from? Do you realize there's no earthly way I could have bought or borrowed even a fraction of what's outside there? You haven't even seen it yet. It's beautiful, Mother. It's wonderful and valuable and unique. And it's appeared here like a miracle. What do you want me to do? Go back and tell some stupid lie about it?"

"I'm not asking you to tell a lie, Tony. Oh, all right, I suppose I am. The point is, if I can't make myself believe in your story, then who *will* believe it? Nobody I've spoken to at home believes it for one single moment."

"All right, Mother, what do you suggest I do? Burn this stuff? Have somebody cart it away to the local dump? Give it to the Salvation Army? And supposing I do that, suppose I then get on a plane and go back to Montreal and next week I wake up one morning and find I've dreamed another dream and there's a whole new lot of stuff outside the window on Mountain Street?"

"That's ridiculous and you know it."

"Why is it ridiculous? Are you so sure I'll never have another dream?"

"Well, all right, I'm not sure. But I'm your mother. And I know that on both sides of the family there never

75

was anything odd, nothing like spiritualism or anything like that. I tell you the honest truth, at the back of my mind I have an idea of what's behind all this. But I'm not going to mention it."

"No, mention it."

"It will only make you angry."

"No, go on, tell me."

"I think it has something to do with Barbara. I think you borrowed this stuff from someone here and you worked up this really crazy story so that it will get a lot of attention and you can stay on out here and not go back to Barbara."

Maloney, despite himself, began to laugh in angry fashion.

"Well, isn't it true she asked you if she could come back?"

"Who told you that?"

"Never mind who told me, it's true, isn't it?"

"Yes. We were supposed to have dinner this week and talk about getting back together."

"Hah!" said his mother, and shook her head angrily, as though on the rim of tears. "I knew it. You don't *have* to take her back. I bet she talked you into it."

"She didn't talk me into it. I didn't even speak to her, I spoke to her sister. Oh, Mother, why do you relate every single thing that happens to me to my trouble with Barbara? You should hear yourself."

"I'm sorry," his mother said. "I told you I'd only make you angry."

"I'm not angry. But you're dead wrong."

"All right, dear. I didn't come all this way to fight with you. No matter what you decide to do, remember I

want to help. Now, listen. I have some savings put away. I want you to have them."

"What for? What's all this about?"

"Well, if you don't go home, you're going to lose your job. And meantime, who's going to pay for all this? Who's paying for those guards out there? This must be costing you a fortune."

He stared at her. His mother who could not believe he would do anything extraordinary, because he was her son. Who offered him her life savings. His mother who sat opposite him in tears in this strange parlor, her hair, as usual, hidden behind a kerchief because there was so little left of it. He knew that. He knew that she felt guilty about the slacks she was wearing because they had cost sixty dollars. He knew that, in compensation, she had bought her blouse in a thrift shop for four dollars. He knew these things because they were the things his mother worried about. She was not equipped to face a twenty-nine-year-old son who had made his dream come true.

And so, going to her, he put his arms around her. "Now, don't worry," he told her. "Look, come outside and I'll show you the Collection. When you see it, you'll realize it isn't just some stunt to avoid taking Barbara back."

It was the right decision. When they went outside, she dried her tears. The Collection was the sort of display she, of all people, would normally enjoy. For the next hour, carefully skirting the pornographic sections, he led her up and down the aisles, watching her particular delight in the exhibits of embroidery, the silverware assemblies, the ceramics and decorated glass. The great crystal fountain by F. & C. Osler sent her into a special

77

gush of praise as he, with some show of erudition, explained how Victoria and Prince Albert had admired it on the opening day of the Great Exhibition of 1851. "Never before," said he, quoting from memory, "had a piece of glasswork been executed involving the treatment in casting, cutting, and polishing of blocks of glass of a size so large and of a purity so uniformly faultless."

"But, Tony, it must be worth a fortune! You must have *several* fortunes here. Why, if you sold off even a little part of this Collection, you'd be as rich as Croesus."

"The police and the American government are now trying to decide whether the stuff is mine to sell."

"It's so gorgeous," his mother said, staring up at the fountain. "Imagine, if the fountain itself were working."

"It works," he said, and pressed a lever. Feathery plumes of water jetted out over the incomparable glitter of glass. The pilasters shimmered wetly, in a kaleidoscope of rainbow prisms.

"Oh, Tony! It's the most beautiful thing I've ever seen!"

Vaterman approached, coming from Bluff Road with a large package of mail. "Hey, Tony? Are you busy?"

"Hello, Fred."

"Lots more press clippings. I was just looking at some German ones. Here—from Oberammergau, even! My father's village."

"Mother, this is Fred Vaterman, who was the first reporter to write a story about the Collection."

His mother, surprisingly, adjusted her kerchief to a more rakish angle and smiled on Vaterman. "How do you do? Did Tony tell you his father was a newspaperman?"

78

"No, Mrs. Maloney, he didn't. Nice to meet you."

"Very nice to meet *you*, Mr. Vaterman. So you were the young man who wrote the first story about this?"

"Yes."

"It must have been so exciting, finding these treasures! I've never seen anything like them. Don't you think this is amazing?"

"Indeed it is, Mrs. Maloney."

"But, there you were, you just went right ahead and wrote about it. And I always thought newspapermen were so skeptical. My husband certainly was. He'd have been sure it was some sort of practical joke, or something."

Vaterman's eyes became wide, unblinking circles. "Practical joke?"

"Yes. You know. A prank."

"Your son is a practical joker?"

"Oh, no, not at all. It was just that, before I saw the Collection myself, I wouldn't have guessed that Tony could dream up something like this. I just wouldn't *believe* it. But now, of course, seeing's believing, as they say."

"And should *I* not have believed your son?"

"Look, Mother, don't go around giving people the impression I'm some practical joker."

"*Are* you a practical joker?" Vaterman said.

"You see? You see what you've done?"

"I'm sorry," his mother said. "Don't pay any attention to me, Mr. Vaterman. I'm always thinking of silly questions and then blurting them out. By the way, Tony, that reminds me, I promised to phone Les as soon as I got here. I want to ask his advice about this."

"Why don't we leave Uncle Les out of it?"

"No. What a thing to say! Look, I saw a phone booth

in the lobby. Let me just give him a buzz, I've lots of change here."

"Mother, I wish you wouldn't."

"I'll only be a minute," his mother said. She went off. Vaterman stared at her departing back.

"If this is a practical joke, then what can be the point of the joke?"

"Fred, it's not a joke. Look, I have to go and shave now. I have an interview coming up."

"But you used to play practical jokes?"

"Never."

In the motel lobby he caught up with his mother as she entered the phone booth. "Mother, I don't want you to mention the words 'practical joke' to anybody else here, do you understand? What are you trying to do, ruin me?"

"What's your room number, dear?"

"Nine."

"I'll come and see you after I talk to Les."

"Did you hear what I said about the practical joke?"

"Yes, I heard you, dear."

In the bedroom he stripped off his shirt and went into the bathroom to shave. The telephone rang in the bedroom. It rang again. Someone picked it up. He heard Mary Ann in the bedroom speaking to the caller. He began to shave. He became aware Mary Ann was standing at the bathroom door. "Tony, can I speak to you for a moment?" she whispered.

"Yes, sure."

"Fred's kind of upset."

"I know. But that's silly."

"Well, Fred worries about people making fun of him. You know—being German and all."

Maloney turned and looked at her. At once, embarrassed, she averted her eyes. "Tell me," he said. "How long have you known Fred?"

"Oh, ever since I got in a hassle with my father."

"When was that?"

"Oh, it's been a while. It's kind of a complicated story, I don't want to bore you with it."

"You won't bore me."

"Well, my father was in the army. He's retired now. Oh, hello, Mrs. Maloney. Did you make your call?"

"Yes, thank you. Am I interrupting?"

"No, no, I have some letters to mail. See you later, Tony."

Mary Ann went out.

"So your secretary comes with you to the bathroom."

"Oh, knock it off, Mother."

"It's none of my business, I know. I just came to tell you that I've spoken to Les again. He's been making inquiries on the legal side. He tells me that if you refuse to return to your classes within the week, the Board of Governors of the university will have the right to break their contract with you."

"He doesn't know what he's talking about. It's nothing to do with the Board of Governors. It's purely a departmental matter."

"Your Uncle Les is a lawyer. Now, don't tell me he doesn't know about contracts."

"He doesn't know university procedure."

"Maybe so. But he's trying to help. And he's partly responsible for the fact that you ever *got* to university, don't forget."

"I know that. For goodness' sake!"

"There's no need to lose your temper, dear. I came here to help you, not to fight with you."

"All right, Mother, I'll tell you what we're going to do. We're going to have a nice dinner this evening, just the two of us, and then, tomorrow morning, I want you to get on a plane and go home. And, above all, stop worrying."

"That walleyed girl has something to do with your staying on here, hasn't she?"

"What walleyed girl?"

"Mary Ann Whatever-you-call-her."

"She's not walleyed."

"No? Her right eye has a definite strabismus."

"Nonsense!"

"Is it? Twenty years as a grade-school teacher, looking at children's eyes for defects, do you think I can't recognize a strabismic condition? It may have been corrected from a more serious squint, but when she's relaxed, her right pupil shows a slight divergence."

"She has a tiny spacing, *very* slight, of the right eye, now that you mention it. I think it's quite attractive."

"So I was right. You're smitten with this girl."

It was always this way. No one loved him more than she did, no one angered him more surely, no one was, or ever would be, the subject of so many broken resolutions to keep his temper. And so, once again, he resolved that, no matter what, they must not fight. "Mother, I have to go for my interview. I'm late. If you ask Mary Ann, she'll arrange a room for you here. I'll come by later to pick you up for dinner. I want us to have a nice evening. And, please, let's not fight."

"I'm not fighting, Tony. You are."

82

They dined at eight. And, inevitably, they fought. They fought about a second phone call which his mother had received from her brother, the ubiquitous Uncle Les. In Uncle Les's opinion, Maloney's story of how the Collection came into being would not stand up in any court of law. Therefore, he would be denied title to the Collection. As for the supposition that the Collection was valuable, Uncle Les disagreed. No collector, in Uncle Les's opinion, would purchase items which, at any moment, might disappear into thin air.

"So you see, Tony, that changes everything, doesn't it? It doesn't matter any more whether the stuff *seems* valuable. In Les's opinion, its value is zero in the resale market. As he says, it would be like buying a card in a three-card trick."

"Oh, forget about Uncle Les."

"I'm just telling you what he said. If you're counting on this Collection to secure your financial future, you're living in a dream world."

"Mother, will you stop it? Will you please shut up? Will you go home, for God's sake! I wish you'd never come."

"I won't say another word," his mother said. "I will hold my tongue and I'll leave first thing in the morning. I'm sorry I'm such a nuisance to you. I really am."

And so, in tears, leaving her veal parmigiana untasted, his mother left the motel parlor and went to her room. Later he knocked on her door. There was no answer.

Next morning he was awakened, at seven, by the telephone ringing at his bedside. "Tony, I'm sorry to dis-

turb you, I know the man at the desk said you don't like to be disturbed. But I just phoned Air Canada and the only direct flight to Toronto leaves at noon. So if I'm going to go home, as you want me to, I'll have to drive to San Francisco at once. I'm going to call a taxi now, and I'll stop by your room to say goodbye. In about ten minutes, all right?"

"I'll get dressed," he said. "Don't call a taxi, Mother, we'll find a car for you. I'd drive you myself, but, as I told you, if I leave here it rains."

"I don't want to be any more trouble."

"It's no trouble."

He found the home phone number which Mary Ann had left with him in case of an emergency.

"Sure, Tony, I understand. I'll be glad to drive her. I'll take her up now and I'll be back by this afternoon."

"Listen, when you get back, maybe you and Fred would like to eat supper with me tonight?"

"Fine, I guess. I'd better check with Fred."

Twenty minutes later Mary Ann arrived and picked up the keys of his rented car. He went down to the lobby to find his mother and, as he did, saw her come out of her bedroom carrying her suitcase, wearing a kerchief, slacks, and the old mink-collared coat of which she had once been so proud. She had not seen him, and as he stood watching her, she turned and walked on toward the front door. Suddenly moved, he went up behind her and caught hold of her, as though to stop her leaving.

"Tony, dear, what's the matter? Wait, let me put my suitcase down."

He held her. He did not speak.

"Are you all right? What's happened?"

"Nothing, nothing. I've got a car for you."

84

"You shouldn't have bothered."

He kissed her on the brow. "It's no bother."

Arm in arm they began their walk to the car. "Mother, I'm sorry about last night. Really sorry."

"I'm sorry too, dear. I shouldn't have mentioned Les."

"Listen, we'll keep in touch," he told her. "Phone me tonight, when you get home. And don't worry. I'll get it all sorted out somehow."

"I hope so, dear. I hope so."

He put her bag in the back of the car.

"Good morning, Miss McKelvey."

"Good morning, Mrs. Maloney."

"It's very good of you to drive me. It's a terrible imposition, I'm afraid."

"Oh, no. It's no bother."

He stood, facing his mother. "Well . . ." he began. But what could he say? She had come so long a way on such a hopeless journey. He had said he did not want her here.

As he stood silent, his mother stared up at him as though he were some impenetrable stranger whose language she did not speak. "Listen," she said, at last. "No matter what happens, don't worry, dear. Remember, there's always a place for you. Remember that, won't you?"

"A place?" he said, stupidly.

"Yes, of course, a place. I mean at home. I can always make up a bed for you in the spare room."

5

On the day of his mother's departure, Maloney faced a new and significant influx of experts. For, on that morning, the Vanderbilt University research group, under the direction of Dr. I. S. Spector, began a series of taped and filmed tests and interviews which, later, became the original source material for all other scholars and reporters investigating the creation of the Collection. In addition, there arrived that same afternoon Henry Prouse, Regius Professor of History at the University of Saskatchewan, and Charles Hendron, Keeper of the Dulwich Memorial Trust. Both were eminent Victorian scholars and had collaborated on a two-volume work entitled *The Lodging Houses of Victorian London*.

Management Incorporated possessed an excellent research department. Some years before, *The Lodging Houses of Victorian London* had been reviewed unfavorably in *The Times Literary Supplement*. The unsigned review was written by Professor H. F. Clews of Yale.

86

Within three hours of their arrival, following inspection of the main facets of the Collection, the new experts called a press conference.

"Contrary to some recent reports in the popular press," Hendron began, "it is our opinion, after a preliminary examination, that this Collection contains many original items, previously seen only in illustration or described in writings of the Victorian and Edwardian eras. For this reason alone, the Carmel Collection is, without doubt, the greatest single collection of Victoriana to have been uncovered in this century."

Professor Prouse, concurring in this opinion, made a further point. "The fact that Sir Alfred Mannings, Director General of British Imperial Collections, has admitted that even he cannot distinguish certain well-known items shown here from the originals in his possession implies that, indeed, this Collection may have come into being in a way never before known to man. I am, myself, no believer in the occult. I am a liberal humanist, agnostic in temperament. Yet I sincerely believe that today, in that parking lot, I was in the presence of what may be, perhaps, the first wholly secular miracle in the history of mankind."

The reporters in attendance at once hurried to their typewriters. Vaterman, who led the pack, wrote an enthusiastic press release which he headlined:

FURTHER EXAMINATION BY EXPERTS
REVEALS GREAT VICTORIAN COLLEC-
TION TO BE A ''SECULAR MIRACLE''

Later that afternoon Brewster announced, "New York is very impressed with this new development. They're going to give the story a full page next Monday, with a piece by me, a side bar by Professor Prouse, and a layout of pictures. That should help."

There were other encouragements. Two television networks called to request interviews. Bourget received calls from reporters asking if he had rooms to rent. A new air of optimism was apparent in the Sea Winds Motel.

Shortly after five, Maloney was taking his daily tour of the Collection when he saw Vaterman and Mary Ann come into the parking lot.

"Hi, there. How was the trip, Mary Ann? Did my mother get off all right?"

"Fine. She's *such* a nice woman."

"Humph," Vaterman said sourly.

"What's the matter, Fred?"

"Fred's still worried about the things your mother said," Mary Ann explained.

"Fred, on my word of honor, my mother doesn't know what she's talking about. Now, why don't we all have supper together tonight? Seven, all right?"

Vaterman sighed, heavily. "If you wish." He turned to Mary Ann. "I want to talk to you. Privately."

"Sure, Fred. Tony, if you'll excuse us?"

"Of course."

They went off together.

Seven o'clock came and went, but there was no sign of them. Maloney waited, disconsolate, in the lobby until half past eight. At that point, Brewster asked him to join him for dinner. Distracted, furious at Mary Ann and Vaterman, indifferent to his present company, Maloney dined in a large group which eventually included Dr. Spector and two editors from a Japanese publishing house. Twice he sent messages to Mary Ann's room in the motel and twice was told that she had not come in yet. At ten, he telephoned *The Monterey Courier* and

was told Vaterman had left for the evening. He then phoned Vaterman's apartment in Monterey, reaching only the answering service.

Then where were they? At ten-thirty, weary of Dr. Spector's questions and Brewster's journalistic anecdotes, Maloney asked to be excused. Dr. Spector, a tall man with a heron's stoop, leaned close. "Are you sleepy? You look sleepy."

"Yes, I am, a bit."

"Then we mustn't keep you. You must not tamper with the dream process. Pleasant dreams, and we will resume our discussion in the morning."

Maloney went to his room. As was his habit on retiring, he locked the door. At that moment, sensing something was wrong, he switched off the room light and ran to the window. Below, in the parking lot, the yellow orb of a watchman's flashlight came into view, dancing down an aisle. It was transected by the beam of a second guard's flashlight. Both lights spun in an idle arc as the guards met, stopped, and lit cigarettes. At that point, furtive, although he did not know why, Maloney removed his shoes, hoisted himself on the windowsill, and climbed down. Stealthily he went toward Aisle III, Shed IV, the placement of which rendered its contents invisible to exterior scrutiny, keeping an eye on the distant flashlights as he ducked into the shed, at the door of which stood a work by Matthew Cotes Wyatt, a marble and bronze statue of a large Newfoundland retriever treading nobly on a squirming serpent. The inscription on the plinth of this statue read: BASHAW: THE FAITHFUL FRIEND OF MAN TRAMPLING UNDERFOOT HIS MOST INSIDIOUS ENEMY. Passing Bashaw, who ap-

peared to guard the entrance, he moved from exterior darkness into the faint golden glow of an oil lamp turned low. The shed contained a bedroom exhibit, the centerpiece of which was an ornate, canopied double bedstead. Built in Birmingham, circa 1851, the bed was of japanned metal with papier-mâché panels, painted and gilt, its canopy adorned with tassels bound in silk. Sitting on the edge of the bed was Mary Ann. She wore a Victorian evening dress of plum velvet, with flared skirt and leg-of-mutton sleeves, black silk stockings, and black velvet pumps. On a chair, in semi-darkness at the other end of the exhibit, Vaterman perched, wary and suspicious.

"Hello, Tony," she said.

Silent, he stared at her. She turned to Vaterman. "I didn't even light the lamp until he was coming down the aisle. So he couldn't have seen us from his bedroom."

Vaterman shrugged slightly, as though unconvinced.

Mary Ann turned to Maloney. "You *sensed* we were here, didn't you?"

"No, not exactly. When I went into my room tonight, something seemed to be wrong outside. I concentrated and something told me that some items of women's clothing had been moved from the Jane A. Wooten Trust Collection and brought here, to this bedroom exhibit in Shed IV."

"Clothing. Was that all?"

"Yes. That dress, stockings, shoes, a corset, underwear."

"But you didn't know that I was here and was wearing them?"

"No."

She blushed. "Maybe that's just as well. I wouldn't like to think you have X-ray eyes."

It was his turn to redden. "No, nothing like that."

"Anyway, aren't these clothes really something?" she said. "Like the corset. How did they manage? I'm not fat, far from it, but I can't even get it to close."

"Ladies' maids laced them up. Tiny waists were prized in those days. Wasp waists, they were called."

"Oh? And the panties are really strange, too."

"Knickers. They called them knickers." He looked uneasily at Vaterman, who sat, silent as a jury.

"But they don't seem to do up behind?"

"They, ah, they open in the rear. There are buttons to, ah, to button them up behind."

"Oh?" To his sudden excitement, she lifted the hem of her plum-colored dress, exposing perfect legs in black silk stockings and mauve garters. She felt under the hem of the dress. "Oh, yes, yes, I've found them. Buttons. Wait."

She knelt on the bed, kneeling up straight as though she were in a pew, her hands fumbling behind under her dress. "There, that's it. Good." She let her skirt drop back into place and sat back on the bed. "I felt so bare behind."

Hoarse, Maloney cleared his throat. "Well, you're certainly what this Collection has needed. A live Victorian girl. You look like a figure in a Pre-Raphaelite painting."

Suddenly, squirming in a return of her habitual shyness, she colored and hung her head. Maloney turned to Vaterman. "Didn't you remember you were to have dinner with me tonight?"

"I'm sorry about that," Vaterman said. "We had to deceive you in order to carry out this experiment."

"What experiment?"

"Tell him about it," Vaterman said to Mary Ann.

"No, you tell him."

"*You* tell him," Vaterman said, loudly. "It was your idea."

"Well," Mary Ann began, in her low, urgent voice. "What we did is, we hid here just after six when the day guards went off duty. We planned to move this clothing I'm wearing back to my apartment after midnight, when the night guards break for their meal. I told Fred that when you dreamed tonight, you would know in your dream that these clothes were missing. And I was right. It's like that magazine article said. You're clairvoyant."

"Maybe he is and maybe he's not," Vaterman said. "He could have noticed some movement down here tonight when he looked out of his window."

"Are you calling me a liar?" Maloney asked.

"No. But you have forgotten something. There are other objects missing. You have not mentioned them. They, also, have been removed from their stall."

What objects? Maloney looked at Vaterman and at once, as in a trance, heard himself say, "You have two glass paperweights in your left-hand pocket. And you have hidden an ivory-backed hairbrush of Indian design under your shirt."

"You see!" Mary Ann, triumphant, sat up in the bed and clapped her hands. "I was right. He knows. There's no mistake about it."

"I'm sorry." Vaterman began to take the objects from his pockets. "And also very pleased. I misjudged you, Tony. You *are* a genius."

"All right, now. Don't anybody move. Easy there."

A security guard, his revolver drawn, stood covering them from the rear of the exhibit. "Oh, excuse me, Professor. I didn't know it was you."

"That's all right," Maloney said. "We're just leaving."

"Didn't see you come in, sir. Thought we'd run into our first bit of trouble."

"That's all right, Hollis. Good night."

"Good night, sir."

The guard withdrew, holstering his gun.

"Well, I suppose we might as well go to bed," Vaterman said.

Maloney went to the lamp. "Ready? I'll just put this out."

"Oh, wait." Mary Ann stood up. "I'd better get out of these clothes. Maybe you'd wait outside for a minute?"

"Oh, come on," Vaterman said, "what's the big deal? We won't look."

And so Maloney found himself facing a mahogany chest of drawers, built in 1838, while, behind him, he heard a rustling as Mary Ann began to remove items K to R in the Jane A. Wooten Trust Collection.

"By the way," Vaterman said. "New York phoned this afternoon and said Radiodiffusion Française wants to do a TV interview next Monday. Will that be all right?"

"Monday? Yes," Maloney said, hoarsely.

To the left, near the oil lamp, stood a Victorian dressing table with two drawers, on top of which was a tray dressing glass tilted at an angle of thirty degrees. Maloney, moving slightly, caught sight of Mary Ann removing blue satin stays, those stays she had been unable to fasten.

"You know about Dr. Spector and the Vanderbilt interviews in the morning? That's at ten in the parlor."

Now she stood, her back to them, wearing long cotton knickers, black silk stockings, frilled moiré garters, and silver-buckled black velvet pumps. As Maloney mut-

tered an affirmative to Vaterman's question, she moved into full mirror view, unbuttoning the back panel of the knickers.

"By the way," Vaterman said, "when I was writing that story today, I turned up the fact that it was Duke University, not Vanderbilt, who was first in this extra-sensory-perception field."

For a moment, the white globes of her pretty behind transfixed Maloney's attention. Then she moved out of sight.

"Yes," he said. "Dr. J. B. Rhine at Duke."

He heard the soft fall of a garment. He tried to maneuver himself to a different angle, closer to the mirror.

"Experiments on the laws of chance, weren't they?" Vaterman asked.

"Yes, with cards and dice."

Knickerless, she sat and removed the moiré garters, rolling down the tight black stockings. Naked, she rose and reached for her own long purple dress. At that moment Vaterman turned to her, casually, and asked: "Nearly ready?"

"Yes, just a moment."

Vaterman was looking at her. *He* could look. In that moment a primal jealousy overcame Maloney and he lowered the oil lamp to a guttering matchlight.

"Oh, where are my shoes?"

"Here they are," Vaterman said.

"Tony, could you turn up the lamp a moment? What will I do with these clothes?"

"I'll put them back."

"No, let me. I took them, after all."

"I know where they go," Maloney said, turning, look-

94

ing at her, then, kneeling, gathering up the garments
still warm from her body.

Vaterman took her arm. "I will take you home."

"Okay. Thanks. Good night, Tony."

"Good night, Mary Ann."

They went out ahead of him. He followed them into
the warm Pacific moonlight and stood, holding her
garments, listening until the sound of their footsteps
diminished. Then, sudden, furtive, animal, he buried
his nose in these, her silks.

The following letter was written to Dr. James What-
more, a psychiatrist, by Dr. I. S. Spector, ten days after
the start of the Vanderbilt University experiments.

Dear Jim,

Thank you for your letter. I was particularly inter-
ested in your comments and queries on how the subject
is bearing up under the strain of constantly dreaming
the same dream. It is, I quite agree, crucial to the
precognitive aspect and is also related, as I've noted, to
difficulties experienced in the Dement-Fisher experi-
ments some years ago. I think you will be interested in
the transcript of an interview which follows, but first,
before I attempt to answer your question about uncon-
scious, or dream, stress, let me mention some of the
conscious stresses which now occupy the subject's wak-
ing hours.

In the first place, he worries about losing his position

as a professor of history at McGill University. Subsequent to his failure to return to his classes last week, the chairman of his department placed him on suspension. He fears that his academic enemies have laid undue stress on the erotic elements of the Collection and have cast doubt on his account of its conception. This, of course, is part of his overall problem in making people accept this incredible happening. As yet, his account of how the Collection came into existence has not been widely believed. While some mass-circulation newspapers, particularly in Europe, have written uncritically of the event, more serious media reporting has tended to be guarded, even skeptical. This irritates him. Indeed, there is a paranoiac tendency evidenced in his reaction to adverse criticism.

Then there is the problem of the Collection's inaccessibility. Because it is not yet open for public viewing, many people suspect some trick. The guards inform me that more than two hundred people are turned away every day. A number of these disappointed sightseers utter insults and abuse which is heard by Maloney as he sits in his motel room.

Lastly, there is the police inquiry into his story, an inquiry which he claims does not bother him in the slightest, as it will uncover no trace of any wrongdoing. Nevertheless, even an innocent man will feel harassed and vaguely guilty when, for the first time in his life, he becomes the subject of a criminal investigation.

I have digressed, I know. You asked me to describe a typical day in the subject's present life.

The day (for all of us here) begins when Maloney wakes each morning. Usually this is between 8 and 9 A.M. It is his custom, he tells me, to get out of bed as soon as he wakes and walk to the bedroom window to make

a visual check that the Collection still stands. He complains that he invariably wakes in a tense and irritable state because "it's exhausting to dream that same dream night after night." Shortly after nine his temporary secretary, a Miss McKelvey, arrives, bringing him coffee, his morning mail, and the newspapers. At ten, he comes to our suite and submits to one or another of our daily series of tests and interviews. This continues until noon when he breaks for a light lunch, which he usually eats in the motel parlor with Miss McKelvey and a young man named Vaterman who handles publicity matters for the Collection. He seems most at home with these two young people, who, like himself, are, in their conversation, undistinguished from the norm of their generation.

After lunch, Maloney usually devotes an hour to meetings with lawyers and publishers on business concerned with future plans for the exhibition and funding of the Collection. This is being arranged through a firm called Management Incorporated and has assumed considerable importance for him in view of his possible dismissal from his university post.

From 3 to 5 P.M. he holds interviews with newspapermen and other media people who have requested interviews. From five to six, he visits the Collection, often in the company of scholars and other experts who have obtained permission to meet him and view the exhibits. This is, undoubtedly, his happiest hour. He delights in pointing out details, and in recalling in what museum, in which book, or set of illustrations, he saw those objects which have not yet been discovered in other Collections. Sometimes he will activate the water pump of the central crystal fountain, or climb into the cab of the South Eastern Railway Company locomotive "Folkstone," a

great favorite of his. At other times he will lecture on specific collections, set a spinning loom in motion, or demonstrate the workings of some moving object, such as an invalid's recumbent chair.

At 6 P.M. he reports to our suite for a further hour's session with members of my team. Usually, these involve testing his precognitive, telepathic, or clairvoyant powers through parakinetic and psychokinetic methods and involving dice, cards, and other stimuli. EEG studies are also carried on in some of these sessions. So far, however, he has shown no evidence of heightened ability in obtaining extrachance scores, nor has he entered trance states normally associated with sensitives.

Shortly after seven his public day ends. At first he ate in the motel, but now he walks to his secretary's apartment, which he and Vaterman are helping her redecorate. Thus, for the past five evenings he has eaten there in the company of the girl and Vaterman. He tells me that when he returns to his motel room he gets into bed and watches television for about an hour, putting out his light about 11 P.M. And each night he has dreamed the dream described in my first letter, the one in which he guards, admires, and patrols his Collection.

I have outlined a typical day. I would emphasize that at no time since I have known him has Maloney, like other sensitives we have studied, withdrawn into any trance or fantasy state. Nevertheless, as you will see from the following transcript of a taping, the idea of a new fantasy does obsess him.

Q. What do you feel when you waken each morning and discover that the Collection is still there?

MALONEY. At first, I feel a sense of relief and pleasure. Maybe *reassurance* is a better word. But then, as the morning wears on, I begin to feel depressed.

Q. Perhaps you are now sorry that you created the Collection?

MALONEY. No, I wouldn't say that. I get great pleasure out of knowing that I did it. But it's got to be accepted, seriously, I mean, by serious people. The answer is, of course, for me to bring another dream of mine to life. That would solve all my problems. It's the one way to make people believe in this present dream.

Q. Have you ever thought of this: Supposing, the moment you dream a new dream and bring it to life, the old dream—the Collection—vanishes? Wouldn't you feel you'd somehow "betrayed" your original dream?

MALONEY. Yes, that's possible. But I'm already "betraying" the Collection.

Q. Why is that? I don't understand.

MALONEY. Well, I've sold an option on it to a consortium of businessmen headed by my agent. They're paying all my operating expenses for six months in exchange for first refusal on exhibition rights.

Q. Why did you do that?

MALONEY. Because it's too big for me to look after myself. These guards cost a lot of money. And there are salaries, my secretary's and Vaterman's, and my own expenses. Besides, if the Collection is to be opened to the public, it will cost a lot to set up ticket facilities and so on. And now I have a court case on my hands. I had to hire lawyers.

Q. A court case?

MALONEY. The State of California has gone to court to argue that, because it appeared here, the Collection is the property of the state.

Q. But there's every chance the court will rule in your favor, surely?

MALONEY. I hope so. But I wonder if it's worth it.

Q. What do you mean?

MALONEY. I mean, I wonder is any one thing of this sort worth devoting one's whole life to it? Frankly, my instinct right now is to go home, forget the Collection, and try to get my old job back.

Q. And forget about dreaming up a new dream?

MALONEY. Let me ask *you* a question. Would you give up your present career as a scientist if you could dream some dream and make it come to life?

Q. Well, I might, if I could dream of a cure for some major disease. Or of broaching some new frontier of the mind.

MALONEY. Right. But those dreams are impossible for me. A man can only dream what he knows. And my field is the Victorians.

Q. Theoretically, through study, it might be possible to alter one's power to dream. As you, by your studies of Victoriana, were enabled to dream up the Collection.

MALONEY. Yes, I've thought about that.

Q. Is there something you've considered studying in order to dream a new dream?

MALONEY (agitated). Let's take a break. I think I've said enough for one day.

7

The telephone, ringing early, roused him from the order of his dream to the confusions of reality, bringing him in off his long night's patrol to a voice, distorted, yet instantly familiar.

"Tony? Is that you?"

"Who is it?" he asked, unnecessarily.

"It's Barbara. Were you asleep?"

He did not answer.

"Well, aren't you surprised to hear from me?"

"I hadn't thought about it."

"I'm calling about our so-called date. It was supposed to be Wednesday, right?"

"It was," he said. "I should have written. I'm sorry."

"I see. I'm told you've given up your job at McGill."

"The job seems to be giving me up."

"And I'm also told you want to sublet the apartment."

"Well, I haven't decided yet. I haven't decided any-

thing. This is a completely abnormal situation, you know. I mean, this thing that's happened to me."

"Never mind what's happened to you," she said. "I'm calling to know what's going to happen to us. And I seem to have my answer, don't I?"

He did not speak. He had not spoken to her since the Sunday morning, a year ago, when she left him. They had been in bed at the time, having a stupid, ordinary row. He had said that the bottle of Château Latour was too good to have for dinner with the Comptons. Jack Compton wouldn't know a bottle of Château Latour from a bottle of Molson's Ale, he said. The Comptons were *her* friends. She got up out of bed, naked, a tall girl with titian-red hair and a mole the size of a quarter on her left shoulder blade. She didn't put on any under-clothes, just pulled on a dress and put her feet into a pair of pumps. Then she went into the dining room of the apartment, took the bottle of Château Latour out of the sideboard, put it under her arm, threw her sheep-skin overcoat over her shoulder, and walked out.

She did not come back. Two days later her sister came and took her clothes away. Later he heard she'd taken a six-months lease on a flat on Sherbrooke Street. She could afford it. She was a talks producer for the Canadian Broadcasting Corporation and earned as much as he. She did not phone him or try to get in touch with him. For a long time after she walked out, he had been lonely and angry and had missed her. But now, hearing her voice after a year of not hearing it, he was shocked by a surge of resentment.

"You amuse me," he said, bitterly, to that voice far away in Montreal. "You walk out, you don't get in touch for a year, and now you want an instant decision on what's supposed to happen to us."

"I don't want an answer, Tony. I think I have the answer. I think we've given it plenty of time and now we should get a divorce. Right?"

"Right," he said, furious. "Whatever you like."

"It's not whatever I like, it's something we should have discussed months ago. I know that's partly my fault. Still, I must say I find it strange that you never tried to come after me."

"You do, do you?"

"Is that all you have to say?"

"Is that all *you* have to say, Barbara?"

"All I have to say is, I thought we were civilized human beings."

"Well, we're not, it seems. So tell your lawyer to write to me, if that's what you want."

"If that's what *you* want," she said. "It's Harry Crenshaw, you remember him?"

"Yes."

"I'll tell him to contact you, then. Is your furniture and stuff still in the apartment?"

"Yes, why?"

"Well, there's the furniture and the silverware and things that were mine before I met you. I could send you a list and we could make a fair division of the stuff, including the wedding presents."

"Fuck the wedding presents."

"What's that supposed to mean?"

"Take them. Take anything you want."

"Well, if that's the way you feel, you'd better send me authorization to go into the apartment and take what I need."

"I'll mail you the key. Goodbye."

He put the phone down. To think he had waited a

year and worried himself sick about not being back in time. To hell with her!

At once, he felt much better. Ten minutes later, Mary Ann knocked on the door. "Ready for your breakfast?"

"I'm getting a divorce."

"Oh," she said, and hung her head. "Is that good or bad?"

"Good. Very good. Where's Fred, is he around?"

"No, he's at the *Courier*. He said he'd be over around lunchtime."

"Okay, let's all have lunch together. Or do I have an appointment?"

"No."

"So, at one o'clock, then?"

"I'll ask Fred."

From the back seat of Vaterman's battered Mustang, en route to the restaurant, he watched as Mary Ann massaged Vaterman's neck. At once an odd, painful jealousy suffused him. He remembered her, half naked, moving around behind the ornate, canopied bed, then pulling down her drawers. Of course, she and Vaterman were sleeping together.

Or were they? And what business was it of his?

Yet, in the Konditorei Karmel, as the three of them stood in line for smorgasbord, hoarsely casual, he put a question. "Tell me, you two. What do you think of having children? What's your attitude?"

Saw Vaterman exchange a glance with her. "Well, I guess Mary Ann and I feel no children, at least not now."

"And what do you feel about marriage? Or do you think people should live together first?"

Vaterman seemed embarrassed. Uneasy, he indicated the food table. "Oh, they have red cabbage today," he said. "It's excellent. So are the dumplings."

Maloney looked at Mary Ann. Her habitual blush moved in an arc from her cheek to the long line of her neck, but for once she did not flinch under his gaze. This time it was he who found himself unable to meet her stare. Guiltily, he spooned dumplings. Better not ask any more questions. Yes. Better not ask.

But some things cannot be avoided. A few evenings later, Vaterman, declaring that they both needed exercise, suggested they play a game of Frisbee on the beach.

"What about Mary Ann?"

"She's taking her recorder class in Monterey from seven-thirty to eight-thirty. We could meet here afterwards and go out to supper."

"Right, Fred. Good idea."

The sands of Carmel are ash gray, the beach swept clean of trash, protected by local ordinance. Long breakers curl and whiten hundreds of yards from shore. Dunes, perennially covered by thick green banana clusters of ice plant, screen the roadside. In the distance, tall groves of Monterey pines hide the houses of the rich who live above the sweep of the bay on this rim of land and sea. In the vermilion backwash of a Pacific evening, Vaterman's bright yellow plastic Frisbee turned black against the sky, spinning like a dish plate from hand to hand.

"Hey, great!"

"It's what we need."

"There you go."

Vaterman, who had removed his safari jacket and shoes, ran angularly about, skidding in the sands, energetically fielding and returning the disk. But Maloney, though out of condition, was more adept than this former European at the basic American game of catch. And so, as play continued, distances grew greater and returns were speeded up until, suddenly out of breath from his undisciplined running, Vaterman collapsed on the sands, panting, his long hair spilling into his eyes. Maloney held the Frisbee in reserve and walked toward Vaterman. In a few minutes it would be dark.

"You all right, Fred?"

"Yes." Vaterman sat up, attempting a smile. Then, as though he heard a noise, he looked back over his shoulder, narrowing his eyes to peer at the dune.

"What's wrong?"

"The father," Vaterman said, as though beginning the Lord's Prayer.

"What father?"

"Mary Ann's. What's he doing here? When we separate, he follows *her.*"

Maloney turned to look.

"He's over there by the path leading down to the road."

There was no one on the darkening dune. No one stood on the steps of the path which led up to the roadway. "I can't see him," Maloney said.

"He just ducked down behind that bench."

"But why does he follow you and Mary Ann?"

"He wants to catch us in bed together. When he does, he's going to kill me."

"You're joking."

"No. He's dangerous. He was an instructor in unarmed combat."

"Oh, come on."

"He's warned me. I tell you it's made my love life quite difficult. I mean, if I try to lay her, I worry in case he's lurking about, ready to rush in on us."

"But doesn't he have a job? He can't follow you *all* the time."

"He's on an army pension. Listen, do you remember the night Mary Ann and I hid in the Collection?"

"Yes."

"Well, between you and me, one of the reasons I agreed to that stunt of hers was I thought I might be able to lay her in that shed. I mean, with the guards around, I was sure he would stay out in the street. But, do you know something?"

"No. What?"

"When we left the shed that night and said good night to you, I saw him in there, hiding behind a booth. It was a good thing you showed up when you did. I was just about to try and lay her on that antique bed."

Maloney felt himself flush. He looked up at the dunes, but saw no one. "Shall we go back now?" he asked.

"May as well."

Together they climbed the steps to Sea View Drive. Street lamps had been lit and lights shone from the picture windows of houses that fronted on the beach. An elderly couple peered out of a passing car. There was no sign of the father.

"Has he gone?"

"No, he's down below there on the beach."

Maloney turned and walked quickly to the beach wall. Below, the ash-gray sands were deserted. Vaterman fell in beside him and they walked in step, the matched tread of their footsteps loud in the silence. "You see, he's an expert at hiding himself," Vaterman said.

In silence, they covered the last blocks to the motel.

"Is he still following us?"

Vaterman turned and looked back. "Yes."

"I remember Mary Ann once mentioned some hassle with him. What was that?"

"You don't know?" Vaterman lowered his voice. "He's sick. I mean mentally sick. Mary Ann's mother died when she was very little. When she was fifteen her father was still giving her baths. Can you imagine?"

Footsteps sounded behind them in the street. Maloney whirled around. A boy ran past, accompanied by a boxer dog.

"When she was seventeen she ran away to San Francisco. And he found her. He told the police she'd stolen money from him. He said she was on drugs. He brought her back to Monterey. That's when I met her. A year later I helped her run away again. She went to Big Sur and hid there with a girlfriend. But he found her. So I helped her move to Carmel and at the same time I wrote him a letter saying if he bothered her any more, we'd go to court and say he'd been messing around with her. Ever since then, he's wanted to kill me."

They went into the motel. No, Bourget told them, Mary Ann had not returned yet.

An hour later, as they sat drinking from a six-pack of beer in the motel parlor, she came in carrying a large

white cardboard box. She unbuttoned a long, frayed cardigan and, sitting down, showed her long, elegant, coltish legs in red suède boots. "I got some stuff from the deli," she said, in her low, urgent tone. "Sandwiches and strudel. I hope that's all right?"

"Fine," Maloney said. "How was your class?"

"Okay. How was the Frisbee?"

"Something very unusual happened tonight," Vaterman told her. "The father followed *us*."

She rose, took off her cardigan, and went to the window. She stood, for a long moment, looking out at the street lamps. "Did Tony see him?"

"He kept out of sight," Vaterman said.

She turned, looked at Vaterman, then went and opened the large cardboard box, took the box and stood before Maloney. "I got pastrami on rye and lox with cream cheese on rolls. Which would you like?"

"Pastrami, thanks."

"You can have one of each, if you want."

"Well, I'll start with pastrami, thanks."

"He has gray hair," she said. "And he has kind of a red tanned face. And he walks with a limp sometimes when his leg hurts. I mean, my father."

Maloney accepted the pickle she offered.

"You *didn't* see him, did you?"

"No."

"He's outside right now, I'm sure of it," Vaterman said. He rose and went to the sandwich box. "I want lox and cream cheese."

Mary Ann ignored the request, not offering the box, letting Vaterman pick out the sandwich himself. Instead, she knelt on the rug, facing Maloney. She looked up at him, like a penitent in the confessional. "He has

gray hair, red tanned face, and sometimes a limp. If you *do* see him, will you tell me?"

"Of course."

"He'll see him all right," Vaterman said loudly. "He may decide to kill Tony too."

Exactly two weeks after the Collection's appearance in Carmel, the winds of Maloney's fortune swept into a strange upturn. It was a time of omens. On that morning, when, as usual, he looked out of his window to check on the Collection, he glanced over at Bluff Road to see if the madman had come yet. For eleven days, the madman had arrived each morning on the stroke of nine, walking up and down until dusk, a tall, unkempt figure, barefoot, shirtless, wearing a greasy black suit jacket and white duck trousers, holding aloft a hand-lettered sign:

GOD ALONE CAN CREATE
Do Not Believe This Lie

Today there was no sign of him. Unaccountably cheered, Maloney began to whistle.

That afternoon, he toured the Collection with Lord Rennishawe, a Hellenist of stature and also proprietor

of Creechmore Castle in Wales, a repository of Victorian treasures which Maloney had visited four years ago, during the period of his doctoral studies. A tiny, frail figure with shoulder-length hair, Lord Rennishawe was sometimes mistaken by shortsighted persons for a ten-year-old girl. This lack of height ran in the family, he told Maloney, and indeed, in Victorian times Lord John Russell, when Prime Minister, had said of the Rennishawes: "If we Russells are members of the race of Great Dwarfs, the Rennishawes are midgets *manqués*."

Lord Rennishawe was eighty-one years old. In his letter requesting permission to view the Collection, he cited a report by Sir Alfred Mannings that certain items of drawing-room furniture in the Collection appeared to be copies of originals in the Glamis Wing of Creechmore Castle.

This proved to be so, and, like other experts who had seen known treasures duplicated in the Collection, Lord Rennishawe confessed that he was unable to distinguish the furniture here in Carmel from the originals in Wales. This, of course, was the sort of confirmation Maloney desired. He was on the point of asking Lord Rennishawe if he would write a letter confirming this opinion, when the tiny old man ducked under the portico of a large model of Heidelberg Castle, execrably executed in cork, and like a child scurried across the model courtyard, opened a cork door, and emerged in the next aisle. "Come here!" he called in his imperious falsetto. "Come here at once, young man!"

Maloney, unable to pass through the model castle, ran down to the end of his aisle, turned a corner, and ran up the parallel aisle. Lord Rennishawe was standing outside one of the furniture exhibits, a room with three walls like those in department-store showrooms. Each

item here was reduced to about two-thirds size, giving it the look of a room in a giant dollhouse. The wall paint, silks, and velvet coverings all were of a peculiar shade of pale green, ornamented in some cases with a subtle phallic motif. The furniture in this green room consisted of a half tester bed, with a chaise longue at its foot, four Eastlake nursery chairs, a tray dressing table with a tray dressing glass on top of it, and a washstand decorated with erotic motifs and executed in the Gothic style in the manner of William Burges.

"*Where* did you see this?" Lord Rennishawe cried, in a quavering, breaking tone.

"Where did I see what?"

"This—this room!"

"I believe it was—yes, this was also at your family seat, Lord Rennishawe. Creechmore Castle."

"When?"

"Well, I was there one afternoon about four years ago, as I told you."

"My God," said Lord Rennishawe. He went to the chaise longue and lay on it. He tested the nursery chairs and, finally, sat on the bed. "Extraordinary. It fits me. It was made for my grandfather. But *you* didn't see it, young man. Nor did you read about it, because nothing, absolutely nothing, has ever been written about it. Very few people ever did see it, excepting a few of the servant class. This room was my grandfather's secret. It was concealed behind a dummy wall in an old summerhouse in the small wood below the south lawn at Creechmore. I know that my father and brothers never saw it. But I did. Yes. It was the midterm holiday and I went down from school to stay with my grandparents. I remember I was about ten at the time, so it would have been nineteen-oh-two. Yes, one afternoon I was flying a kite

on the south lawn. The kite got away, floated up over the wood, and got stuck in a treetop. I went into the wood and climbed up the tree to extricate my kite. While I was up there I heard the sound of footsteps. I looked down and there, below me, running as though frightened out of her wits, was a young servant girl, an under-parlormaid, I think. Her dress was open, unbuttoned all the way down, and I saw that she was naked underneath. I remember I was very excited. When she reached the edge of the wood, she gathered her dress together, holding it modestly closed over her bosom, and went around the edge of the south lawn to the servants' quarters, which are just behind the main house.

"I collected my kite and climbed down, in great haste. I wondered where she'd come from. I turned and went back a little way along the path and came to the old summerhouse in the clearing. I'd been forbidden to play there, because, my grandmother said, it was dangerous, and ready to collapse. Well! There was the summerhouse, all right, and standing in the doorway, smoking a cheroot and holding a brandy glass in his hand, was my grandfather. In some disarray!" Here Lord Rennishawe uttered a high, childish giggle. "No trousers, you see. In his undershirt. And behind him I saw, like a stage room in the foreground, the old summerhouse with moldy rattan chairs and table, and behind it, where the wall had been, this more intimate room. The green room. This very room. Well!

"And at that moment my grandfather looked up and saw me. I remember I was quite afraid. I was very young, but I knew I'd rather walked into something. Well! He had great panache, my grandfather. He greeted me quite casually, invited me to step inside, and

then told me this was his secret place, where he came sometimes to read or have a nap. Then he put on his trousers, quite unconcerned, and took me into the secret room and showed me how the wall rolled back, and so on. And as I stood there, by this very bed that you see, I noticed the young maid's chemise and white cotton drawers lying on the floor. I can remember them to this day. Well, my grandfather slid the wall back into place and then swore me to secrecy, made me give him my word of honor that I wouldn't tell it to a living soul. I was quite afraid of him, you know. Well! A few days later, when I went back to school, he slipped me a little change purse as a present and in it were five sovereigns. Another secret, he said. So there it was. I didn't tell anyone. And a few years later I heard that my grandmother had gone down to the old summerhouse one night and had an accident with a lamp there and that the place had burned to the ground. Of course I knew why. Oh yes. And, a few years after that, I decided to tell my sister Antonia. We were very close at the time. But she was shocked and made me promise not to tell anyone else. She said it would hurt Mamma if it got out. Well! And here it is. The selfsame room. Look, that was his special color, that shade of green. And d'you see these little touches, the phalli on the embroidery of the coverlet, the little lascivious cupids there on the ironwork of the washstand. Extraordinary! Oh, there's no doubt about it. You could not possibly have had access to any documents describing this room. There *are* no such documents. You are a necromancer, a wizard! This Collection of yours is undoubtedly one of the most astonishing events of the century!"

Lord Rennishawe's excitement was such that he could not contain it. Before the day was out, he had repeated

his conviction in several newspaper interviews and had agreed to appear on a network television talk show on his way home to Wales, via New York. He proved, by virtue of his great age, his clear diction, and his minuscule size, to be a memorable television guest. As he told his story, television cameras probed the contents of the secret chamber, and this story, more than the original story of the Collection itself, at once piqued public fancy and resulted in a rash of publicity, all of it in a tone markedly less skeptical than that which had greeted Maloney's original announcement.

The upturn continued. Within a week, Maloney was notified by letter that the F.B.I. investigation had been dropped, for lack of evidence of any criminal intent or connection. Lieutenant Polita of the sheriff's office was still keeping his options open, it seemed, but, for the moment, had been temporarily transferred to a more urgent case. In the same period, a federal judge handed down a verdict in Maloney's favor, stating that the Collection would seem to be his property and that the State of California could claim a share of the revenues from its public exhibition only were it to be exhibited exclusively within the state.

Perhaps the most significant of all these reactions was the way Lord Rennishawe's statement was received in Maloney's native city. Again, in that same euphoric week, as he was leaving the motel one evening to dine at Mary Ann's apartment, he received a call from Montreal. The caller was John Palliser, a friend since high-school days and now a member of the history department at McGill.

"Tony, is that you?"

"Hey, John. Good to hear from you."

"I didn't wake you up, did I?"

"No, it's early here."

"Well, it's just after midnight here and I'm still so wound up, I had to call you. You know what happened tonight? There was a great big meeting in the Union. All about you, Tony my boy. It was really something."

"About me?"

"Yes, in protest about what the department's done to you. The response has been terrific. It started with that story, day before yesterday, by that English lord, saying your Collection was one of the great events of the century. Frankly, that really switched a lot of votes in your favor. Nobody can accuse Lord Rennishawe of being a phony, now can they?"

"No."

"Anyway, suddenly everybody began talking about the injustice of it, the university suspending you and so on. And then all over campus we began to see these posters, protesting on your behalf. Students did it. Amazing. And then some of us in the department got together and tonight we held this protest meeting. You should have seen the crowd. First I spoke, then Jack Monsey, he's the head of the student council, then Lise Roy, and, anyway, after the meeting we got signatures from graduate assistants and teaching staff. I tell you, Tony, we can close down the whole damn history department unless they reinstate you at once."

"Reinstate me?"

"They fired you, didn't they?"

"Yes, they did, but I can't blame them, really. After all, they have to have somebody to teach my classes."

"Come on, Tony, what are you talking about? The rest of the staff could have divvied up your classes and handled the extra load. We weren't even consulted. Listen, how long are you going to be out there?"

"I'm not exactly sure."

"Well, what are your plans? I mean, we only know what we read in the papers, but my understanding of the situation is, you're trying to arrange some funding to permit the Collection to be exhibited out there, right?"

"Yes, that's right."

"And once that's arranged, I assume you'd want to come back here and get on with your own work."

"Well, you know the situation's very complicated."

"You haven't been offered another teaching job, have you?"

"No."

"Then they had no right to fire you."

At that moment, as in a dream, staring out at the darkened aisles of the Collection, Maloney seemed to see an audience of faculty and students sitting in the great darkness of the Union while the opening speaker, John Palliser, adjusted the microphone, turning it up to emit its usual harsh shriek. Then John's voice, booming out—"no right to fire this man"—a call for justice there in that familiar atmosphere of cigarette smoke and the damp of winter woolens.

"Tony, are you there? Look, as I said tonight in my speech, we can all talk about scholarship and so on, but what more creative scholarship can anyone imagine than to re-create the artifacts of a period simply through an act of the imagination? Any university but dear old McGill, my God, they'd be so proud of what you've done. But we Canadians, we never recognize originality, because we have no real use for it. We *fire* the man who thinks up something new. My God, think of it. This is the academic scandal of the century!"

A scandal. John's voice crying scandal, as hundreds

rise to their feet, applauding, cheering, calling for a demonstration. From now on he, Anthony Maloney, would be a campus hero, controversial, whispered about in the faculty club, pointed out to outsiders as he crossed the campus on his way to class. All he had to do was go home.

"John, listen, I'm very grateful to you. It was damn good of you to organize all this for me."

"Nonsense. It's not just your friends, Tony. After that Rennishawe story, *everybody's* beginning to have second thoughts, believe me. We're going to win this one. We don't want to lose you to the United States. You've got to come back, dammit. We're proud of you."

Proud of him. Emotion overcame him, hearing these words.

"Anyway," John was saying, "this is long distance and it's late. I'll write to you tomorrow and give you the battle plan. Take care, Tony. And good night."

"Good night, John. And thanks."

Excitement, as if he had just drawn an outstanding hand at cards, filled him as he replaced the receiver. A full house of people assembled back there in Montreal, a flush of students, faces blooming upward. A campus hero. A hero who gave up fame in the States for the cause of academic justice. I am a historian who was witness to that first moment in history when a man's dream literally came true. I could work up a course, say, on the Victorian era as a factor in modern man's historical consciousness, an extension of my Ph.D. thesis. I'd be an outstanding lecturer, unique in my field.

He went into the bathroom to brush his teeth. Brushing vigorously, bending toward the white concavity of the washbasin, he saw, in the porcelain, white snows, snows which covered the lawns at McGill, saw the path,

brushed clear, leading up to the library, saw himself walking up the path. Students paused to stare and whisper, breath pluming from their mouths in the cold morning air, as he moved on, an academic hero, the man who had dreamed up the world-famous Great Victorian Collection in faraway Carmel.

He put down his toothbrush and stared at himself in the mirror. Now there, he told his mirror self, there is a fine dream for you. If I could go to bed tonight and dream that I will return to Montreal in triumph, with all this behind me.

He shut off the bathroom light, returned to the bedroom and sat, pensive, on the bed. To dream myself into some happier future, to dream the thing I want most and make that dream come true: that would be ideal, wouldn't it? Of course it would.

But to dream oneself into the future would be to obliterate the present. If his dream succeeded, would the Collection simply vanish in the miasma of his future?

Remorse, totally unexpected, totally affecting, suffused him. How crass to even think of erasing his dream! He rose, went to the bedroom window, climbed out, and dropped to the ground below. He began to walk down the center aisle, staring up for a moment at Osler's crystal fountain, seeing the myriad panes of glass glisten in the stark Pacific moonlight. Turning into Aisle IV, he came to one of his favorite exhibits, the paintings by Victorian Royal Academicians. His hand, as though guided, reached out and found a small kerosene lamp, which he lit, adjusting the wick to a modest flame. Raising the lamp to look around, he was at once confronted by a circular oil painting executed by Charles Baxter, entitled *The Sisters*. Pubescent, soft

garments spilling about snowy shoulders, liquid eyes wide in what waves of childish innocence, or wise in what hidden schoolroom depravities, *The Sisters* silently reproached him for his faithlessness in wishing to abandon them. Faithless, he turned away to be met by Sir Edwin Landseer's monument to fidelity, *The Old Shepherd's Chief Mourner,* a highland collie on his last lonely guard duty, his nose across his master's coffin. Rebuked, Maloney moved out of the shed, still carrying the oil lamp. Opposite him now was one of the most peculiar rooms in the Collection, a room which experts said did not exist, a room he had read about in an obscure volume only available from the Reserved Shelf in the British Museum. This was the receiving room of Mrs. Beauchamp's bordello in the Strand, a musty parlor adorned with obscene wall panels, its furniture heavy and serviceable, many horsehair poufs, large tête-à-tête sofas in stuffed plum velvet, chaise longues plumped up with blue swansdown pillows, brass spittoons, and small brass side tables of Turkish design. A smell of long-ago cigars, patchouli, and cheap scent lingered still: on these very chairs and sofas, mustachioed males had lolled, regardant, as Mrs. Beauchamp clapped her hands and the parade began: the girls, young, working class, awkward, sauntering across the room in an attempt at grace, plump naked thighs peeping from beribboned drawers, hair cascading about their white shoulders, chemises with cherry draw-string ribbons undone to reveal erect nipples; shy half smiles directed at the fuddled male stares. And later, what scenes of cruelty and vice would be enacted in the curtained alcoves, under the infamous series of paintings depicting *The Lion in Sinful Love* and showing the King of Beasts engaged in bestial dalliance with three terrified

nymphs. Maloney stood at the threshold of this room, his lamp highlighting these very solid objects, objects which today existed only because he had dreamed them into life. How could anyone abandon such things? It would be worse than neglect: it would be a crime.

But as he put the lamp down on one of the brass tables and sat, like one of those Victorian dandies, on the buttoned, tufted, tête-à-tête sofa, a new thought came into his mind. *This room is empty.* No seventeen-year-old whores parade here before waistcoated gentry and Piccadilly swells. There is no life in my creation. There are no living figures. How can I give up my future happiness for a series of empty rooms?

He went out, going down Aisle II, passing the Ross telescope, the 1842 model of Liverpool docks, the Coalbrook Dale Dome and two casts of Arabian horses, "in most spirited attitudes," owned by the King of Württemberg. He lingered briefly by John Bell's statue of Andromeda exposed to a sea monster, staring at her buttery breasts, the full cornucopia of female belly, the pupil-less eyes. And as he looked into those blank Grecian orbs there came to his mind Mary Ann's vivid, unusual features, her lips lit by a smile, her sudden, shy blush, her awkward, coltish movements, her long, elegant legs in their red leather boots.

But how could he go on living with a set of statues? A man must live with a real woman. How could anyone spend his life wandering up and down the aisles of a museum, night after night dreaming the same dream? After six months, after a year, he would no longer be able to look at all this. He would grow to hate it.

He lifted the kerosene lamp and blew into the glass funnel, extinguishing the flame. Retracing his steps, he left the lamp where he had found it, under the painting

of *The Sisters.* Then, reaching his window, he climbed up, re-entering the motel room. He closed the blind and suddenly, as though decided, undressed and got into bed.

He would make himself dream that he was back in Montreal, reinstated, promoted, with all his troubles behind him. He would dream of his future, a year from now.

But as soon as he had decided this, for a moment, like a thief, the Collection slipped back into his mind. If he now dreamed of that future life, he might never see the Collection again. By dreaming of leaving it here, in the past, he would be willing its destruction.

Fear gripped him. But I mustn't give in, he thought. I must renounce the Collection. I will renounce the Collection. I renounce the Collection!

He closed his eyes. After a moment his panic subsided and, as in a dream, unbidden, an image, reflected in a tray dressing glass, came to him: the memory of Mary Ann as he had seen her that night she changed her clothes in the bedroom exhibit. As in a dream, he watched her unfasten the blue satin stays, revealing long white cotton knickers, black silk stockings, frilled moiré garters, and silver-buckled black velvet pumps. She bent slightly, unbuttoning the back panel of the knickers. The panel fell away. As the white globes of her pretty bottom filled his mind, he sank into a hot, drowsy doze.

For a long moment he dozed, luxuriant, watching the movements of her naked behind. And then, as she had that night, she moved out of mirror range. The looking glass went blank. He tried to turn to find her, but his head seemed caught in some terrible vise. He was forced to remain staring at the blank tray dressing glass. It

124

blurred, then changed. Now he saw that it was no longer a Victorian looking glass but a television screen, the screen of one of those surveillance monitors one sees in supermarkets. In dream, he stared at this screen, hoping to see her reappear. Instead, he was presented with a long view of one of the aisles of the Collection. For thirty seconds the scene remained stationary. Then, with a flick of the picture, the camera eye moved on to scrutinize another aisle. Maloney lay in his bed, forced to monitor this dream monitor.

The new dream was infinitely more exhausting than his former patrol dream. In the earlier dream, he had moved about the Collection at will, often in a state of wonder and delight, pausing to examine and admire the many facets of his Collection. But now he was shown only an overall, distant view of each aisle, the camera holding on yet another dreary passageway. And where, formerly, he had seen the Collection, in dream, in all its wonderment of shades and colors, now each aisle appeared to him only in the fuzzy blue-gray hues of black-and-white television. Trapped, unable to deflect his gaze or turn off the monitor, he lay for eight hours, a prisoner of this banal and terrible spectacle.

He woke. It was morning. At once he looked over to the corner of the room. There was no television set on the wall. He sat up, swung his legs to the floor and stood, trembling, sweating, filled with the panic of a man who tries to escape from a burning building. But when he moved forward, he fell, his limbs like deflating balloons. He lay, face down, on the floor.

Someone knocked.

"Tony, are you awake?"

Dr. Spector's voice.

"Yes," he called, in a voice weak as his limbs.

"Just to remind you our interview's at nine. See you then."

He heard the footsteps retreat. Bracing himself like a man attempting a pushup, he tried to stand, but lacked the strength. He lay, his heart pounding, his face on the polyester carpet, abandoning himself to a nameless, hopeless panic. After a time he heard a second knock. That would be Mary Ann. The door was locked from inside. With a tottering lurch he gained his feet, moved two steps to the door, scrabbled with the key, and, when it turned, fell, exhausted, to his knees. She entered, carrying his morning coffee.

"What's wrong, Tony? Are you sick?"

He looked up at her, unable to speak. At once, putting down the coffee, she knelt beside him. "Tony, answer me? Are you all right?"

With a gasp he sucked in breath and then, bowing his head, rested it on her shoulder. "I've got to get away from here," he whispered. "I've got to get away at once."

"Wait." She helped him to his feet. He stumbled to the bed and sat heavily on it. "I have to go. I must go now."

"But you're not able to go anywhere. You're sick."

"If I can get in the car, I'll be all right."

"Where do you want to go?"

"Please. Just help me."

"Of course I will. But first I've got to speak to Fred."

He sat in trembling unease as she went to the phone. He heard her ask Vaterman to come over at once. When

she had finished, she came and sat on the bed beside him. "Now tell me. What happened?"

He caught his breath again. "Is the Collection still out there?"

She walked to the window. "Yes, it's there. Nothing's changed."

"What color is it?"

"What do you mean? It's all colors."

"Not just gray?"

"No. Tony, what happened?"

"I don't know," he said. He put his head between his knees as if he would be sick. "Last night something went wrong with my dream. I can't go through it again. I can't."

"Can't what? What is it you can't do?"

"I can't stay here. I want to go to some other place, some city, Los Angeles, maybe. I could get to Los Angeles by tonight, couldn't I?"

"By car? Sure."

"All right, then, will you help me get out to my car?"

"Fred will be here any minute. Here, try some coffee."

"No, thanks. Please, I want to go now."

But she shook her head, her mane of hair hiding her face. "Wait. I promised Fred."

"Promised what?"

"Nothing."

He turned from her and lay back on the bed. His trembling increased. He heard someone come into the room. He heard her whisper, then heard Vaterman's voice, whispering in reply. He could not distinguish what they were saying. He summoned his strength and said loudly, "Will someone help me get up?"

Vaterman loomed over him, distorted, at an angle. "Why do you want to go to L.A.?"

He shut his eyes. They were worried about what would happen to the Collection if he left it. He would have to tell them something.

"Tony?" Her voice, murmurous, low, very near. He opened his eyes and looked into her face. "Tony, I'm going to call a doctor."

"No," he said. And at once it came to him. "No, don't do that," he said. "I'm going to dream a new dream. But I have to get away from here to do it."

"A new dream?" Vaterman said, excited. "Well, why didn't you say so in the first place. Listen, I'll drive you to L.A. I mean, if you have a new dream come true, I want to be first with the story. Right?"

"But what if it rains while he's gone?" Mary Ann asked.

Maloney, with a great effort, raised himself in the bed. "Nothing's going to happen. I promise you."

"How do you know?" Vaterman said.

"I know. Now, let's go."

"First," Vaterman said, "I had better call my paper and tell them what I'm up to."

"No, don't tell anyone. I don't want Dr. Spector or anyone else following me. We're going to sneak out through that window."

"Right." Vaterman seemed excited. "We will use my car. And Mary Ann can stay here and watch the Collection in case there are changes."

"Oh, please, Tony," Mary Ann said. "Please, let me come with you."

Maloney stood and, with an effort, walked toward the window. "All right," he said. "Yes, let her come."

Red blurs appeared before his eyes. He staggered. Vaterman took his arm and whispered, "Mary Ann, go and bring my car around to the parking-lot entrance. We'll meet you there. Steady, Tony."

Buzz Harvey, the senior Securigard officer on duty that morning, later reported that about 9:15 A.M. he saw Professor Maloney climb down from his bedroom window and come, stumbling, along the main aisle of the Collection. He was followed by Mr. Vaterman, who carried a small bag of the overnight type. When Maloney rose, he seemed shaky. He put his hand over his eyes.

"Are you okay?" Vaterman called out.

"Yes. Where's your car?"

"This way."

Harvey reported that he went up to Maloney at that point and asked if he could be of assistance. Maloney shook his head and, following Vaterman, went toward the entrance to the parking lot. The usual crowd of would-be sightseers was peering in from the roadway. Maloney, Harvey reported later, "walked real slow, like an old man. He looked very sick."

A few minutes later, Vaterman's car drove up to the entrance to the parking lot. Miss McKelvey was at the wheel. Harvey and Vaterman helped Maloney cross the aisle and get into the car.

"Goodbye, Buzz," Vaterman said.

"Goodbye, sir. Going for a drive?"

"Yes."

As Harvey went to close the back door of the car, Maloney, sitting in the back seat, put his head between

his knees. "Hurry, hurry!" Harvey heard him tell Miss McKelvey.

The red Mustang eased its way past the usual double line of parked tourist cars, which extended for two or three blocks up Bluff Road. After turning onto Sea View Drive, it stopped outside Mary Ann's apartment.

"Don't stop," Maloney called out.

"Only be a minute," Mary Ann said. She ran inside. Vaterman took the wheel. A few minutes later she ran out wearing a long yellow dress, sandals, and a sheepskin cape. She carried an airlines flight bag.

"And away we go," Vaterman said, putting the car in gear and swinging out suddenly into traffic. "Los Angeles, here we come."

"I love L.A.," Mary Ann said. "Fred, remember last time, when we went dancing on the Strip and stayed up all night?"

Maloney lay back on the seat, staring through the window at the metallic California sky. At Salinas, they turned south. The red Mustang roared on, past row on row of lettuce fields, moving onto an eight-lane highway, among a rush of traffic flowing southward. Vaterman drove with total concentration, rarely taking his eyes off the road. Mary Ann occasionally looked back to check if Maloney was all right. He did not speak to them. He remained slack on the seat, staring up at the harsh sky.

Time passed. At Pismo Beach, where they stopped for coffee and sandwiches, Maloney refused to leave the car. And when Mary Ann suggested phoning Carmel to find out if the Collection was still all right, for the first time,

ever, he shouted at her. "Don't phone, dammit! I don't want a whole lot of people following me."

"I'm sorry." She went off with Vaterman to the restaurant. Alone in the car, Maloney closed his eyes and inadvertently found himself drifting toward the rim of sleep. But panic floated back. He sat up straight, remembering the surveillance dream.

After what seemed a long time they returned to the car, Mary Ann carrying three boxes of Cracker Jack. "I phoned Carmel," Vaterman said. "And you'll be interested to know that your prediction is correct. It is not raining in Carmel. The Collection is okay."

"I told you not to call Carmel."

"And I am telling *you* I am not your servant!" Vaterman shouted.

"Anyway, Fred didn't say where he was calling from," Mary Ann said. "He didn't tell them a thing."

They drove on. Mary Ann munched Cracker Jack. In late afternoon they merged with the giant snakes-and-ladders scramble of the Los Angeles freeways.

"Where do you want to stay, Tony?"

"Any place. I don't know."

"Let's stay at that hotel on the Strip," Mary Ann said. "Same as last time."

At once, Vaterman slowed the car to about forty miles an hour. "You mean the Sunset Plaza?"

"Yes. It's okay, isn't it?"

Vaterman did not answer. A moment later, he turned the car onto the San Diego Freeway ramp. "We have company."

Maloney sat up straight, in new panic. "Who?"

"Mary Ann's father. See that green Chevy that's been following us, over there in the left lane?"

Maloney looked through the rear window. There was

a Chevy in the left lane. Its driver was a stout matron wearing a red and yellow bandanna kerchief. "Are you sure? There's a woman driving."

"She is probably some friend of his. He is crouching down in the back seat."

Maloney looked over at Mary Ann. "What do you think?"

"I wish I had more Cracker Jack."

"It's not a time for jokes," Vaterman said crossly. "This means separate rooms."

She stared ahead obliquely. "Whatever you say."

Minutes later, the Mustang left the concrete anonymity of the freeway, moving into the sad, billboard-blighted streets of Hollywood as though crossing the frontier from an advanced to a backward country. Maloney saw the green Chevy move past, going on down the freeway toward San Diego.

"You seem to have lost him."

Vaterman shook his head. "He will come off at the next exit."

"But how will he find us? We'll be miles away by then."

"He will find us," Vaterman said.

The Mustang went up Doheny Drive, turning onto a hilly street lined with buildings resembling huge blocks of multiflavored ice cream. Vaterman pulled into a driveway which read S U N S E T P L A Z A H O T E L & A P T S . It seemed to Maloney not appreciably different from the motel he had fled. "It's nice," Mary Ann whispered. "And it has a great pool."

132

"I don't want a room overlooking the pool," Maloney said. "I want to look out at the street. Or, better still, at a blank wall."

"Why's that?"

"I just do, that's all."

The room clerk to whom Maloney later made this request was a young man of considerable sophistication. "Agoraphobia," he said. "Yes. You'd be surprised how many people are hung up on that. Let's see. I can give you 14A, which has one small window facing a blank wall about twenty feet away."

"Good. And I want the television set taken out of the room before I go up there."

"Right. If you'll just wait a minute."

A sixteen-year-old bellhop, dressed in blue jeans and pink-and-white-flowered shirt was sent upstairs to remove the television set. Later, he escorted Maloney to a small second-floor room. A single bed faced the window with its promised view of a nearby wall. After the bellhop had accepted money and left the room, Maloney moved the bed so that it faced away from the window. He then went to the window and looked out. The window gave on a narrow alley in which a row of cars was parked. The wall, some twenty feet away, was blank, windowless brick.

There was a knock on the door.

"Come in."

Mary Ann entered, tentative, almost furtive. "Can I see you for a moment?"

"Of course."

"I just wanted to apologize about Fred. You see, he gets real cranky if he feels people are ordering him around. If you don't mind, please try not to make him mad. Okay?"

"Fine," Maloney said. "I was a bit cranky myself today."

She smiled her shy, awkward smile and tossed her mane of auburn hair. "Anyway, Fred doesn't like L.A. Last time we were here, I kept him up dancing all night."

"You like to dance?"

"I love it. But, I mean, we won't be doing any of that this time. With your dream, and all."

"Never mind my dream. Let's go dancing tonight."

"Oh no." She laughed, embarrassed. "No, really. Besides, you need to rest. You look tired."

"I don't want to rest. I'd like to go dancing. Let's go dancing."

"Are you sure?"

"I'm sure."

At that moment, inadvertently, he saw the window and the blank brick wall. "First, I want a drink," he said. "I want a drink right now. Let's go out to some bar, okay?"

"Okay."

There was a knock on the door.

"Who is it?"

"Me. Fred."

She went to open.

"Ah, so here you are. I was wondering where you were, Mary Ann."

"We were just going to go out. Tony wants a drink."

"He's found us," Vaterman said. "I told you he'd find us. I have a room that looks on the street. I looked out and a green Chevy went past, very, very slow. I went downstairs just now to check. It is parked at the end of the street."

"All right, let's go out. Tony wants to go to a bar."

"Tony?" Vaterman said. "Before we start off, I want to ask you something. When do you think I can file a story back to the *Courier?* I mean, they don't even know I've left Carmel."

Maloney ignored this. "Let's go."

"We could go to J.J.'s," Mary Ann suggested. "They have drinks and food too, if anyone's hungry."

"Just a minute," Vaterman said. "Tony hasn't answered my question."

But Maloney was staring at the blank wall outside. "It's not night yet," he said.

"What do you mean?"

Red blurs came before his eyes. His head throbbed.

"I said, what do you mean."

"I mean I'm not sleepy. I want to have some drinks. And then I want to dance. Mary Ann, you want to go dancing, don't you?"

"Well . . ." She looked to Vaterman for guidance.

"What's this about dancing?" Vaterman said. "I thought you came here to have a new dream? How can you have a new dream if you're out drinking and dancing?"

"Let's get that drink," Maloney said, loudly.

"Fred," Mary Ann whispered. "Please? Get the car."

Hours later, in a club like a barn, vast, windowless, strobe lights prismatically piercing the gloom, rendering all vision a simulacrum of drunkenness, sound a cacophony so total that no other noise could penetrate the iron heartbeat of the music: in this place, her feet now bare and black with dirt, Mary Ann danced, a creature transformed, possessed, her shyness vanished like a stammer, pausing between sets only to drink

another Coca-Cola, her feet still moving restlessly to remembered music, her hand beckoning Maloney once again onto the dance floor as he, coatless, disheveled, drunk, reeled and whirled in parody to her virtuosity. While at their table, weary, nodding with sleep, Vaterman sat like an old man in an asylum, forgotten in this great screaming throat of sound.

"I want to talk to you," Vaterman shouted, raising his voice in a rare moment of silence.

"Fred wants to go home," Mary Ann said.

Vaterman turned on her. "Oh, shut up! Listen, Tony, I have a story to file. I did not come to L.A. to sit in a goddam dance hall. You said you were going to dream a new dream. How can you dream a new dream when you're drunk?"

"I'm not sleepy yet," Maloney said, and held out his hand, beckoning Mary Ann onto the dance floor, walking away from Vaterman's shouted complaints. When they returned from the set, the table was empty. A note was propped up against the lamp.

Gone home
Careful: The father is outside.
FXV

Mary Ann read the note and crumpled it into a ball. "That means he's mad at me."

"Who? Your father?"

"No. Fred."

"Tell me something," Maloney said. "Why would your father drive all the way to Los Angeles and yet never speak to you? It doesn't make sense."

The cymbals clashed. The lead guitar player screamed into the mikes. All speech died in the train

wail of the music. Again he led her to the floor, his drunken vision kaleidoscopically fragmenting her moving torso in the flicker of the strobes. The question he had asked blurred and was lost, as in these several hours of spastic movement he seemed to have lost the reason for his panic and flight. Yet the panic, dulled by uncounted Scotches, waited to surface again.

At last, a great crash of sound and, suddenly, strobe lights were shut off, music died, and the barnlike ceiling of the dance hall was revealed in electric whiteness. The performance was over. The stage, an empty tangle of wires, mikes, amplifiers, stood in trashy confusion, silent as a carnival midway when the crowd has gone home. Mary Ann still gyrated, lonely on the dusty floorboards. "What happened? It's not over, is it?"

"Yes, it's over. Band's gone."

"What time is it?"

"I don't know," he said. "Let's go some place. There must be other places."

But the teenaged troglodyte who guarded the cloakroom offered no hope. "It's after four. You won't find no place. Maybe some bar with music, or something."

"Then let's go to a bar. Okay, Mary Ann?"

"Okay." She took his arm and led him toward the door. "You know," she said suddenly. "You're fun. Did you know that? Fred isn't fun, you know."

"I know. Let's find a bar. I think I need another drink."

A yellow cab, lonely American survivor among the late moving shoals of foreign cars in Beverly Hills, found them and removed them to a go-go bar. Naked girls undulated to recorded music in a cage high above the dance floor.

"Hey, good music," Mary Ann said.

He stood, staring at the jukebox, suddenly remembering the television dream. His panic surfaced.

"What's the matter?" she asked.

"Nothing. Let's dance."

They danced. He drank. An hour passed. By now, the go-go girls had gone. There were four other customers in the bar, none sober.

"Do you think your father's still hanging about?"

She shrugged.

"Do you really think he followed you down here?"

"Fred says he did."

"But *you* didn't see him?"

"No."

"Do you ever see him?"

"Oh, sure. At least I used to. He used to come up and talk to me in the street."

"What did he say?"

"Oh, he'd ask if I was being a good girl. Stuff like that. Hey, what's happened to the music?"

"We can put quarters in that jukebox. I'll get some."

But, going toward the bar, Maloney tripped and fell. She helped him up. "You're really high tonight, aren't you?"

He looked at her, her face now close, her luminous eyes concerned for him, her auburn hair tumbling about her cheeks. All at once, he felt as though he would weep. "You know," he said, "my life is going to be lonely from now on."

"What do you mean, Tony?"

"Nothing. Let's dance some more."

"Are you sure? Maybe you want to call it a night?"

"Not yet. Let's dance."

But, minutes later, suddenly, unmistakably ill,

Maloney sought the men's room. A wrong turning led him out into a back alley. There he retched and, sobered, raised his head and saw bright sunlight on the pastel alley wall. The night had passed. He went back into the club.

Alone on the tiny dance floor, she moved in response to those intricate rhythms which had animated her through the night. The three remaining customers, all male, focused on her with blurry concentration as, feet bare, her long hair damp, her white dress clinging to her elegant, coltish legs, she gyrated in trance, her large luminous eyes dreaming of some unending rhythmic paradise.

"Mary Ann? Mary Ann?"

The music ended abruptly with a sudden scud of drums.

"Mary Ann, it's morning."

"Yes, and I'm going to close the place," the bartender told the room. "You can get yourself some breakfast at the pancake place up the street."

"Good idea. Hey, Tony, let's get some breakfast."

At the House of Pancakes, she ate a double order of eggs and blueberry pancakes, with a side dish of pistachio ice cream. Maloney drank black coffee.

"That was really fun tonight, wasn't it? You know, that was the best fun I've had in a long time. What's Montreal like?"

"It's nice. You'd like it."

"We should go there sometime."

"What would Fred say?"

She looked at him oddly. "What do you mean?"

"I mean, you're Fred's girl, aren't you?"

She looked away. "I'm not anybody's girl," she whispered. "That's the truth."

The middle-aged waitress who had served them breakfast came up, with a small prefatory cough.

"Excuse me, folks."

Two younger waitresses materialized behind the first waitress. All wore uncertain smiles.

"The check," Maloney said, dutifully.

"We have sort of a bet going," the older waitress said. "I wonder, can I ask you a question?"

"What is it?"

"Are you the gentleman we saw on television, the one with that collection up in Carmel?"

"Yes, I am."

"I win," the younger waitress said.

"Thank you," said the older waitress. "And it certainly is an honor meeting you."

When the waitresses had gone, Mary Ann suddenly said, "I just thought of something. You didn't sleep at all last night. Yet, when you sleep, it's to guard the Collection. Supposing something's happened to it?"

"Let me worry about that."

She blushed. "I'm sorry. It's just that sometimes I feel like I'm a part of the Collection. I don't know how to explain it. It's silly."

"No, it's not," he said. "Maybe you *have* something to do with it. But supposing it did vanish last night. Supposing I have to go home to Montreal and take up the life I had before this happened. Would you just forget about me, in that case?"

She shook her head, her auburn mane hiding her

140

features. "Anyway, nothing's going to happen to the Collection, right?"

"Right," he said.

In the taxi, going down Sunset Boulevard, he said: "I'm serious. Would you come to Montreal with me if I asked you?"

She put her hand on his knee. "Shh!"

"Would you?"

"I really had a nice time last night," she said. "Didn't you?"

"I'd get my job back. I'm hoping to be made an associate professor soon. Then I'll have tenure."

"What you need now is a good sleep."

"Sleep?" His panic floated upward for a moment.

"Sunset Plaza, was it?" the driver asked.

"Right," Mary Ann said.

"I don't want to sleep. I wish we could go on to Montreal right now."

Mary Ann was silent.

"I mean it."

The cab entered the hotel driveway. Mary Ann got out first. Maloney, following her, fumbled with a fistful of bills, overtipping the driver, spilling money on the asphalt walk. As he bent over to pick up the bills, he became aware that his drunkenness had worn off. His hands trembled. His panic floated up, full-blown.

As they went through the lobby to get their keys, red blurs came before his eyes. He took his room key. 14A. The bed; the blank wall. His head throbbed. The hues of black-and-white television came down like a screen over his vision, and endless, monotonous as rows of cells in a prison corridor, the aisles of the Collection held in

the unblinking scrutiny of the television monitor, un-moving, grim, strangely terrifying as though, like some maze, once entered, its labyrinthine silences would imprison him forever. He began to tremble. And then, as though he were regaining consciousness after an anesthetic, the red blurs returned. His head cleared.

In front of him stood Mary Ann, key in hand, waiting for the elevator. "Could I stay with you?" he heard himself say. "I don't mean sleep with you, but could we just lie down together?"

He saw her flinch. A red welt of embarrassment laid itself like a stripe across her cheek. "Why?"

"Because I'm afraid to be alone."

She turned away, as though to hide herself from his eyes. The elevator came. The doors shut on them and the elevator began its climb. It reached her floor. Suddenly, in awkward haste, she took his arm. "Come on."

He began to tremble.

She came from the bathroom, toweling her long dark hair. She wore a white cotton nightgown with Mexican white-flower embroidery at the collar and shoulders. She looked at him.

"Take your clothes off and take a shower," she said. "It'll make you feel better."

Obedient, he went toward the bathroom. As he passed, she lay down, languorous, in the narrow bed.

In the shower his panic was such he stood for a long time unable to move from under the jet of water. To sleep and not to dream. Not to dream. He said it over and over like a prayer. When at last he came from the bathroom, still trembling, wearing only shorts, Mary Ann had already dozed off. As he crossed the room, he

stumbled against the bed table. A Gideon Bible fell with a slap on the floor. She woke.

"Pull the blind down before you come to bed," she said.

In the new darkness of the room, he lay beside her, trembling. She turned to him and stroked his chest with long, delicate fingers. "Now go to sleep," she told him. "Everything's going to be okay. And when we wake up we're going to have a nice day."

He nodded. Within moments, she was asleep again. He closed his eyes, waiting for the appearance of the television monitor in some corner of the bedroom.

After a while he opened his eyes. In the maw of his panic, he steadied himself and, leaning on one elbow, looked down at the girl who lay asleep beside him, her dark hair tousled like a child's, the sheet kicked aside by her long, naked legs, her white cotton nightdress rucked up to show the delicate oval of her buttock. For one tantalizing instant she became a Victorian servant girl asleep in an attic bed while he, the young master of the house, looked on her nakedness, possessed of the *droit du seigneur* to her sleeping charms. But in that one giddy flush of desire, panic returned like an attack of nausea, to float him down a new and vertiginous slope. She slept now, but could he? What if, away from Carmel, *all* sleep would be denied him?

Trembling, sweating, catatonic, he lay, open-eyed, for the next two hours. It ended with a knock on the door.

"Mary Ann? It's Fred."

She sat up, startled, in the confusion of a person wakened from deep sleep.

"Mary Ann?"

143

Her finger went to her lips, then pointed to the bathroom. An instant conspirator, Maloney rose and tiptoed across the room. As he closed the bathroom door behind him, he heard her call: "All right. Just a minute."

He stood by the tub, trembling, hastily putting on his clothes. He heard her open the bedroom door.

"What time did you get home?"

"Around eight."

"Eight? So you were out all night with him."

"Yes, we were dancing."

"Your father is going to kill him. You know that, don't you?"

"Oh, come on."

"I am serious. When I left the club, he did not follow me. He must have stayed there all night, watching you and Tony."

"Well, *we* didn't see him."

"Where is Tony?"

"In bed, I guess."

"He's not in bed. I have been three times to his room. A few minutes ago I got the bellhop to use the passkey. The bed is not even slept in. Perhaps he has run off again?"

"Oh, he'll turn up."

"Did he say anything to you before you left him?"

"I think he said something about phoning Carmel. Why don't you go down to the desk and check if anybody saw him go out?"

"Good idea. I'll see you in a few minutes."

The door shut. She came into the bathroom.

"Hurry. Go to your room before he gets back. Did you sleep?"

"No."

"Oh, poor Tony. Listen, I'll talk to you very soon."
She leaned toward him, kissed his cheek and, at the same
time giving him a little push, bundled him out into the
corridor. He went toward the elevator and pressed the
button. The elevator was slow in coming. When it did,
Vaterman was in it.

"Tony, I've been looking for you everywhere. How
are you?"

"Tired."

"I've just talked to Carmel. They tell me it was on
television last night that you've disappeared."

Television. A familiar unease filled him. "How is the
Collection?"

"What?"

"The Collection. Is it all right?"

Vaterman seemed nonplused. "I suppose so. I didn't
ask."

"You didn't ask?"

He rushed past Vaterman, stepped into the elevator,
went up to his room and, agitated, his hands trembling,
put in a call to the Sea Winds Motel. Bourget answered.
"Oh, it's you, Professor. Listen, Mr. Hickman just flew
in, he wants to talk to you."

"No. Get me Dr. Spector."

"Hold on."

"Spector speaking."

"It's Tony Maloney, Doctor."

"Tony, where are you? Are you all right? Why did
you go off like that?"

"It's an experiment, Doctor. I'm sorry, I couldn't tell
you about it beforehand. Did you look at the Collection
this morning?"

"As a matter of fact, I did."

145

"Was there any change in it?"

"No. I didn't look very closely, mind you."

"Well, please go and look now."

"All right, but what do I look for?"

"Some kind of damage. I'm not sure what."

"Hold the line," Dr. Spector said. "I'll be right back."

While Maloney waited, Hickman came on. "Ah, so there you are. What are you doing in L.A.? All right, don't answer, I don't want to make waves. Frankly, I'd have appreciated it if you'd been able to let me know your schedule. Just when we're right in the middle of the franchise negotiations, just when public opinion is beginning to *buy* the idea of the Collection, you disappear."

"I had to. It was an experiment."

"Okay, so it was an experiment. So the Collection is still here. So that stuff you told me last week about it raining if you leave Carmel isn't true. Tony, if *I* can't be sure you're telling the truth, who can? You understand this isn't a criticism."

"If it isn't a criticism, then what is it?"

"Okay, okay. I'm sorry. Tony, I just wish you'd take me into your confidence, that's all. I want to help. Listen, how long are you going to stay in L.A.?"

"I don't know. It depends."

"Well, try to get back as soon as you can, will you? We've got a lot riding on this deal."

"All right."

"Okay, then," Hickman said. "Take care."

Alone again, Maloney began to tremble as he waited for Dr. Spector to return to the phone.

"Tony?"

"Yes, Doctor. What happened?"

146

"Well, what can I tell you? Of course, I'm not an expert on Victoriana, so my observations are without scientific merit. So, when I say I detect some change, it's nothing I can put my finger on. It's as if the objects I examined just now were a little—shall I say—a little more worn than before. I am sorry I can't be more definite. It could also be because there's some coastal fog here this morning and the quality of light is not as strong as it has been on other occasions."

"They've faded," Maloney said.

"Excuse me?"

"They seem faded, don't they?"

"Yes. Yes, that's how I would describe it. Tony, do you realize this is an excellent example of precognition. This is one of the few times in which your experience parallels that of other sensitives. I wonder if you would sit down now and try to write out a full description of your feelings?"

"I'm sorry, Doctor, I can't at the moment. I'll talk to you later."

After replacing the receiver, Maloney called the desk and told the clerk he was not to be disturbed. He locked the bedroom door, pulled down the blind, and lay on the bed, trembling, facing the wall. When had the deterioration begun? What had caused it? Was it the television dream, or was it his absence? Or was it the fact that he had not slept at all? He did not know, he no longer knew anything and so, in alcoholic malaise, he lay, nodding toward sleep as might a person driving a car late at night, desiring it, yet fearing what it might bring, a limbo in which he passed an hour, then an-

147

other, trembling, exhausted yet always and ineluctably awake.

Shortly after noon he rose, shaved, dressed, and went to her room. He knocked. Vaterman admitted him.

"Ah, so there you are. We were told you were sleeping and that you mustn't be disturbed."

Behind Vaterman was Mary Ann, still in her short nightgown, sitting at the dressing table, carefully combing her long hair. On another table were paper cartons containing Chinese food.

"Any luck with the new dream?" Vaterman asked.

"No."

"So, what are you going to do? Go back to Carmel?"

"No, I'm staying here, at least for one more night."

"But that is irresponsible," Vaterman objected. "I have been talking to Hickman about the franchise negotiation. He wants you back in Carmel."

Maloney did not answer. He did not answer because, at that moment, vomit rose in his throat. He hurried into the bathroom, kicking the door shut behind him as he bent over, retching into the toilet bowl.

"Tony, are you all right?" Mary Ann's voice outside, soft, worried.

"Please, go away. Go shopping or something. Give me a couple of hours."

"Are you sure you'll be all right?"

"Yes."

Again, he retched. After a while he heard her call out a goodbye, heard Vaterman say something he did not catch. He stood up and washed his face and hands in the washbasin, then went back into the bedroom. Vomiting had purged him of yet another defense against sleep and

now, as he sat on her bed, he no longer seemed able to maintain his balance. He fell like a rag doll face down on her pillows, smelling her strange girlish scent.

So it had not been destroyed by his flight. No floods or rainstorms had come to sweep it away. Instead, it was fading, cracking, deteriorating. All those strange and wonderful things were becoming damaged. The longer he stayed away, the more they would diminish, like invalids suffering some wasting disease.

He had thought he could destroy it at will. All he had to do was run away. But now he knew there would be no easy escape. The destruction of the Collection would take years. It would die a lingering death, in continuing reproach to his neglect and indifference. Better not to think about that. But, in his desire to reverse this frightening thought, his panic dropped into the opposite fatal chamber. What if he could dream no dream at all, away from Carmel? What if he could not even fall asleep, away from Carmel?

He sat up, stiff with tension. Nausea rose again. On his way, hurrying to the bathroom, he stumbled and fell, knocking over a table which held the remains of the Chinese meal. Cardboard cartons of fried rice and almond chicken fell about him on the rug. He did not get up, but lay prone, his hands pressing into the rug's pile in an effort to control his uncontrollable tremor. Sooner or later, everyone must sleep. Sleep was life's other half. Without it, a person would collapse into madness and death.

After some minutes, he got up off the floor and telephoned down to the hotel desk. Later, pale and sweating

149

but filled with desperate determination, he got out of a cab and went into an office building off the Sunset Strip. There a doctor recommended by the hotel clerk examined him, told him he had a temperature and a high pulse rate and, grudgingly, wrote a prescription for a small amount of Nembutal tablets. Shortly afterward, Maloney returned to his hotel, having filled the prescription at a nearby drugstore. He went to his room and left instructions that on no account was he to be disturbed. He locked his door, swallowed three pills, pulled the blind down, and lay on the bed, face toward the wall.

At eight o'clock that evening, Mary Ann came to his room and knocked on the door. His voice, drained, weak, called out at once. "Come in."

She found him lying half dressed on the bed, trembling, sweating like a man in a high fever and pathetically glad to see her.

"Oh, poor Tony, what's happened? Hadn't I better get a doctor?"

"No, no, just stay with me. I thought nobody would ever come."

"We were told you were asleep. In fact, Fred's downstairs waiting for the result of your new dream. He'd be mad at me if he knew I came up here."

"I can't sleep. I took pills but I can't sleep. Mary Ann, stay with me, will you? I don't want to be alone."

"Of course I'll stay. Should I order up some food?"

"No, let's go out. Yes, that's a good idea. Let's go out. Let's go dancing again. When I'm dancing I don't think about anything. Yes, let's go dancing."

"But you're sick."

"No, I'll be all right. Honestly."

She hesitated. "Are you sure?"

"Yes, I'm sure."

He sat up in the bed and, unsteady, got to his feet. He went into the bathroom and toweled his face and neck. With shaking fingers he knotted his tie and put on a jacket. "I'm ready," he said. "Do you want to check with Fred?"

She looked at him and suddenly shook her head. "No. Come on. Let's go."

9

But Vaterman was waiting in the lobby.

"No dream?"

"No," Maloney said. "We're going dancing. Want to come?"

"Oh, for Christ sake. All right, that is the end of it. I am going back to Carmel first thing in the morning."

"Suit yourself."

"And if you are not ready to come back with me by eight o'clock, both of you will have to find your own transport."

"Fine by me," Mary Ann said. "Now, are you coming dancing, or aren't you?"

Vaterman stared at her. "Goddamn you," he said.

Yet, at four in the morning, he was still with them, driving the battered red Mustang along Santa Monica Boulevard in search of the Big Bomb Club, a place

which the parking attendant in their last spot had assured them stayed in session until dawn. Maloney, who had danced or reeled about constantly for the past six hours, sat slack on the back seat. He had drunk a great deal of bourbon and had been sick twice in men's rooms. He looked abject.

Vaterman, more out of temper than ever, peered from time to time into his rear-view mirror. At last he announced, "I thought so. Here he comes again."

"Who?"

"The father."

"Where?" Maloney asked.

"See the green Chevy coming up behind us?"

" 'S not green."

"It is green," Vaterman said. "You are too drunk to know the difference."

The neon sign of the Big Bomb Club loomed on their left. The Mustang pulled in under a dusty porte-cochere. Long-haired boys and girls, coming out of the club, stood about in the parking lot, eyes dulled, waiting for carhops to find their cars.

"Pretty," one of the boys said, as Mary Ann got out of the Mustang. "Hi there, pretty girl."

Vaterman caught Maloney's sleeve. "Listen, I warn you, the father hates long-hairs. Let's get out of here." He leaned forward and called from the car. "Mary Ann, get back in. We're leaving."

She turned, flushing, and then, suddenly, leaned into the car and whispered to Maloney: "Come on, let's go inside."

"Don't listen to her," Vaterman said. "If you do, when you come out of here you'll find that maniac waiting to murder you in the parking lot."

Flushing, Mary Ann waited. Maloney opened the car door and got out. At once, Vaterman leaned across the front seat, slammed the door shut, gunned the engine, and, with a roar, the Mustang shot out of the club entrance as though escaping from a bank robbery. Maloney looked around. There was no sign of any Chevy. Mary Ann, walking ahead of him, went in at the club entrance. In the tunnel gloom inside, a long-haired youth stood behind a ticket counter. "That will be six dollars each," he warned. Sound eddied over and around his voice, diminishing it to a whisper. They walked toward electronic furor and within moments were again on a dance floor, she moving in synchromesh to the beat; he, clownish, reeling, out of step, in a poor mime of his fellow dancer.

Between sets, he stood at a long bar, drinking a brown liquid the barman said was wine.

"Mary Ann?"

"Yes, what?"

"Fred's going to be pretty angry, isn't he?"

The music started up.

"What?" He screamed the question.

"I don't know. Let's dance."

Two hours later, on the stroke of six, the Big Bomb fizzled to silence. As the few remaining patrons emptied out into the parking lot in search of their cars, Mary Ann and Maloney, hand in hand, walked unsteadily along Santa Monica Boulevard.

"See any green Chevrolets back there?"

"Don't worry," Mary Ann said. "Hey, I really had fun. Didn't you?"

"Yes."

"I mean, I feel we kind of got to know each other on this trip, didn't we?"

"Yes, didn't we."

"It was like a vacation. And now it's ending. I mean, for me. You had a bad time, I know."

"Listen," he said. "It would have been worse if you hadn't been here. You're an angel, do you know that?"

She looked away, embarrassed. They walked, searching the sparse dawn traffic for a taxi.

"What are we going to do?" she said after a while. "Are we going back to Carmel?"

His head throbbed. Suddenly, imposed on his vision, the monitor screen with its television gray blue image panning past the "Folkstone" railway engine to hold on an aisle of the Collection displaying a range of William Morris furniture. Panic, the trapped panic of a prisoner waiting a dawn summons to judgment, filled him. Red blurs came before his eyes. His vision cleared, revealing pale stucco buildings and ugly advertising hoardings in silhouette against a pale pink Pacific sunrise.

"No," he said. "I want to go on."

"Where?"

"I don't know. Montreal. Maybe I can have a new dream there."

She looked at him and, suddenly, smiled. "All right. Why don't we go, then?"

"Now?"

"Yes."

"Do you mean it? What about Fred?"

"I don't have to ask Fred. I'm not married to him."

"That's right, you're not."

155

"Hey, there's a taxi."

"There's someone in it."

They walked on. It was after seven when, still walking, they reached their hotel. They crossed the lobby, hand in hand. The desk clerk, a knowing type, reached around behind him and, in silence, handed them the key to Mary Ann's room.

"I'd like my key as well," Maloney said.

The desk clerk smiled. "Whatever you say."

Hand in hand, they went into the elevator. There were no other passengers. As they went up, she leaned over and kissed him, clumsily, on the cheek. Tears came to his eyes. She likes me. She wants to be with me. I'm no longer all alone. "Listen," he said. "I'm going to go to my room and try to sleep for an hour or two. Then we'll go on to Montreal."

"All right. Will you tell Fred?"

"Okay."

When Maloney reached his own room he at once phoned Vaterman. "Fred, I'm going on to Montreal this afternoon."

"Montreal?"

"It's part of the experiment."

"What's Hickman going to say? You are supposed to go back to Carmel."

Maloney felt himself begin to tremble. "And, by the way, Mary Ann wants to come with me."

"I do not think that's wise, Tony."

"What do you mean, Fred?"

"Mary Ann is a minor. The father is following you. If

you transport her to another country, there may be all sorts of legal actions he can take."

"Surely he wouldn't follow us all the way to Canada?"

"Why not? Anyway, it is your funeral. I am going back to Carmel."

"All right. Listen, I'll phone you from Montreal."

"As you wish," Vaterman said coldly.

"And I'll take good care of Mary Ann. Don't worry."

"Why should I worry?" Vaterman said. "She is your problem now. Don't say I didn't warn you."

The phone clicked.

For a moment Maloney pondered ringing Vaterman back and trying to end on some more friendly note. But was it possible, considering the circumstances? He thought not. He went into the bathroom, removed his shirt, and washed his head and torso in warm water. Then he swallowed three Nembutals, pulled the blind, and lay down on the bed. Nembutals, drink, exhaustion: it had to work.

But it did not.

At ten he phoned Air Canada, then shaved and packed his overnight bag. He sat in a chair until eleven. At eleven-ten he rang Mary Ann and asked her to get ready. There was a flight for Montreal at one.

"Did you talk to Fred?"

"Yes, he's going back to Carmel."

There was a silence. Then she said, "All right, I'll meet you in the lobby in half an hour. Did you get to sleep?"

"Yes," he lied.

The plane climbed. The captain spoke: "Today our route will take us over Las Vegas, Nevada; Salt Lake City, Utah; and, moving on, to Omaha, Nebraska. Then into Chicago and across Lake Michigan to Toronto and Montreal, Canada."

He sought Mary Ann's hand and held it. The captain continued: "Our flying time will be four hours and forty-eight minutes and we expect to land in Toronto at eight-fifty local time. Weather conditions are excellent, but while we don't anticipate any turbulence, we recommend that you keep your seat belts fastened, as a precaution. Thank you. Relax and enjoy your trip."

She turned to him, her dark eyes widening in alarm. "What's the matter? You look terrible."

"I feel sick."

"Why don't you try to get some sleep? Rest your head on this pillow and I'll make sure nobody disturbs you."

Gratefully, he accepted the little pillow and closed his eyes. Perhaps on a jet, thirty thousand feet above the world, he would be freed from the dream, or freed to dream? But, as always on this odyssey, sleep refused him. Dazed, he lolled in the anesthetic drone of the engines. Guilt, the continuing guilt of his abandonment of the Collection, came up in strong panic waves. Would the fading increase as he distanced himself from Carmel? Or did the fading depend on the amount of time he remained away from the Collection? He resolved to call Dr. Spector as soon as he reached Montreal.

In Toronto they were told they must disembark to clear Canadian customs and immigration. In the vast terminal, slack-kneed, erratic in his walk, he followed her

158

down corridors to the customs desk. The officer who took his passport singled him out instantly.

"Say, didn't I see you on television? Aren't you the man who says he 'dreamed up' all that furniture and stuff out in California?"

"Yes."

The customs officer turned to tell his fellow officers. Three of them stopped work to stare. "Well," said the first officer, "no point asking you if you have anything to declare. You could have a whole warehouse full of stuff hidden away in your head."

Two of the officers laughed immoderately. The third whispered something to the first officer.

"Oh, yes. Seriously, sir. You're sure you don't have any forbidden items? Pornographic books or pictures?"

"No, no."

"There were a number of items of that nature turned up in Carmel," one of the other officers said loudly.

"All right, sir. Will you just open these bags?"

The search was thorough; the manner cordial.

"The young lady is with you?"

"Yes."

"No liquor or gifts, have you, miss?"

"No."

"All right then, you can both go ahead."

Weary, his head aching, Maloney went back with Mary Ann to reboard for Montreal. But now things had changed. No sooner were they in the air with the seatbelts sign turned off than a woman passenger carrying a Polaroid camera came down the aisle. "May I take your picture, Professor Maloney?"

Mary Ann began to comb her hair.

Flashcubes flared. Suddenly the aisles were filled with passengers. Some asked for autographs, some merely

stood about, watching, whispering, giggling. A stewardess forced her way through. "Dr. Maloney, if you and the young lady wouldn't mind, I think you'd have more privacy in first class."

In Montreal, the airline provided a "complimentary" limousine to bring them into town. As it glided away from the airport, the driver respectfully requested a destination. Maloney sat silent. He did not know where to go. Barbara had been up to his apartment. He had been told she had stripped it, taking all the sheets and blankets, the silverware, and most of the furniture. No one, not even his mother, knew he was here. And, as he gave the driver the address of a downtown hotel, it came to him that for the first time in his life he was entering his own city as a stranger.

A stranger, but not unknown: when their bags were brought in from the limousine, an assistant manager, magically apprised of their presence, appeared to show them to a special suite. Within the hour, two newspapers had called to ask how long he planned to stay in Montreal. Was it true he was planning to take the Collection on tour? Was he, perhaps, planning a permanent home for his Collection in Canada?

At nine-thirty he saw his photograph flash on the television screen. The announcer said he was traveling with his secretary and staying at a downtown hotel. Against his better judgment, he then made a telephone call.

"Mother?"

"I just saw you on TV! Where are you? What are you doing staying at a hotel, you could stay here, is it because of having that girl with you, listen, I could make

some arrangement and put her up too. I'm not *that* narrow-minded."

"Mother, it was very sudden. I just called you tonight to say hello, because I want to get some sleep now. I'll speak to you tomorrow."

"Can I tell John Palliser you're here? He's very anxious to see you. It's wonderful what he and the others have done for you at McGill, isn't it? Such a nice boy, John."

"Mother, I'll call John tomorrow. I'm dead beat. And promise you won't tell anyone else where I am."

"Well, I think you should at least say hello to Les tonight. He's going to feel hurt."

"No, Mother. I'll do it in the morning. Now, good night. Talk to you tomorrow."

He ordered the hotel switchboard to hold all further calls. He went to the window and looked out at the great dominoes of lighted windows, tall office blocks abandoned to night cleaners. Beyond was the long sprawl of the city's east end and, far away, across that black band of night which was the St. Lawrence River, the firefly glimmer of dwelling lights on the farther shore. Here he had been born twenty-nine years ago in a hospital room in Notre Dame de Grâce; here, a child in a Red River coat, he had skated in Westmount Park; here, in the ugly classrooms of Verdun High School, he had begun the metamorphoses of an ordinary life: a schoolboy, overeager, quickly discouraged; a university undergraduate who would one day become a university professor; a son who would become a husband; a lover who would again be alone. In all these years he had moved anonymous in the veins of these streets, a microcosm of his city. But tonight he had lost that anonymity and, in losing it, had become estranged.

161

He turned from the window and as in confirmation of his changed status saw the unfamiliar elegance of the suite. He sat on a Biedermeier sofa in the sitting room and looked at the shut Empire doors of the adjoining bedrooms. At that moment a drowsiness overcame him. His head lolled forward and he closed his swollen eyelids. At once, as if caught in a vise, his neck stiffened and his eyes again saw the gray-blue image moving slowly past the "Folkstone" railway engine to hold on that aisle of the Collection which contained a display of William Morris furniture. But this time, even in the blurred hues of television, the stalls gave off an air of decay, a sense of abandonment, the stillness of a burial ground. Red blurs came before his eyes. His vision cleared. He awoke, calling out her name.

She came at once from the bathroom, wrapping a large white towel around her. "Tony? Are you all right?"

"Yes," he said. "Let's go out."

"Are you sure? Aren't you pooped?"

"No," he said. "I want to take you some place. You want to see Montreal, don't you?"

"Well, yes. Whatever you like."

"All right, then. Hurry and get dressed."

She ran back into the bathroom. Within moments, like an obedient child, she reappeared wearing her long yellow caftan. "Ready," she said.

He looked at her, longing, with the hangdog stare of love.

André's Grande Allée was a student rendezvous. In it, Maloney had first been introduced to his wife. Before

and after that event he had spent uncounted evenings there with friends, drinking beer, dancing, making it a night with a supper of André's pizza special. Even the graffiti scratched on the walls of the men's room were so familiar that, unintentionally, he had memorized most of them. To walk into André's was, in a sense, to come home. Home is where the expected is ordinary. In all these ordinary evenings, no famous, dangerous, or outrageous events had occurred within these walls.

Until that night. For, when Maloney and Mary Ann entered, they found themselves the cynosure of the room, focus of a wall of unremitting stares. Momentarily he thought it was because of Mary Ann, a girl unlike any other he had ever escorted to this place. But when René Turcotte, the manager, led them at once to the choice reserved tables by the dance floor, sweeping off a "Reserved" sign as he seated them, and ordering a round of beer on the house, the evening became as no evening at André's within Maloney's memory. Students he knew, and scores he did not, began pointing him out, granting him that total attention he had sought from them in vain in all his classroom hours. Seeming to want to touch him, they pressed close: "You're Dr. Maloney, aren't you?" or, "Hi, sir, remember me?" while others simply bobbed their heads in uncharacteristically humble nods of recognition, muttering half sentences like prayerful ejaculations: "Fantastic, I tell you!" — "Really far out."

Far out. At last, like a dream come true, he had been granted instant canonization as a patron saint of youth. "I hope they reinstate you right away, sir, I surely don't want to miss your class," a pretty American girl told him, respectfully laying her hand on his sleeve. "Yes,

they'd better get their heads straight in that history department," a red-haired basketball giant warned. "Right on!" cried the giant's outriders.

The music struck up. Mary Ann, ignored by his fans, smiled at him hopefully across the table. Rising, he led her onto the dance floor. And now, as in a scene from an old film, when, clumsily, he began to orbit his lissome partner, the other dancers stopped dancing and crowded around to watch. For a few moments he and Mary Ann were the only couple moving on the floor. Then, respectfully, the rest of the dancers resumed their dance.

"It felt like we were on show there," she said, blushing furiously. "I nearly died, didn't you?"

They danced. As soon as they returned to their seats, they were again the center of a crowd of admirers. Strategists of his reinstatement offered questions and advice. It became more difficult to get back to the dance floor. Beer did not lift him into the requisite state of drunkenness. The questions and conversations made his head spin. Shortly after midnight, watching him shuffle his feet on the floor, pretending to dance but scarcely moving from one spot, Mary Ann whispered: "Why don't we go home? I'm dead tired and so are you."

But it was not easy. When he tried to pay his bill, new friends and eager strangers protested his departure, then offered to drive them to some other place. Outside in the street, more students materialized in the guise of autograph hunters, and when, at last, they found a taxi and drove back to their hotel, a young man waiting in a white station wagon across the street jumped out and ran up to Maloney. "Mr. Maloney, I'm from CKHL's Nightwatch program. You wouldn't care to come along to our studios and talk with our Nightwatch host, Don Ireland? He's waiting for you right now."

"No, thank you."

"Well, perhaps in that case we could set up something for tomorrow night?"

"I'm not sure where I'm going to be tomorrow night."

They entered the hotel lobby. The elevator came. As it climbed to the fifteenth floor, Maloney, suddenly dizzy, put his arm out to steady himself and caught hold of her in what must have seemed like an embrace. At once, she moved close, her breasts pressing against his chest. As his vision cleared, he found himself staring into her dark eyes, eyes like those of the older of the pubescent sisters in Baxter's Victorian portrait, and for a moment it seemed to him that he held that innocence, that long-ago girlishness re-created as flesh and blood. Lust stiffened him, lifting him from his drunken exhaustion. He ran his hands down her long back to fondle soft buttocks, his lips seeking the cleft of her throat.

"Let's go to my room," she whispered.

Her voice broke the spell. It was her voice, American, not that long-ago English lisp. He remembered that he had not called Dr. Spector. He had gone through the entire evening without one thought of those treasures wilting away in Carmel. *The Sisters.* Perhaps, even at this moment, the canvas was cracking, obscuring those dark, liquid stares.

When they went into the living room, she threw down her cape and shyly put up her face to be kissed. Trembling, he turned his head away. For one electric moment she stared at him, her cheeks red, then, snatching up the cape, ran into her bedroom. He ran after her and caught hold of the bedroom door.

"Mary Ann, I'm sorry."

165

"Nothing to be sorry about. You're tired, that's all. See you tomorrow."

He heard her lock her bedroom door. He stood trembling for a moment and then in sudden panic went to the telephone and called Carmel. "Mr. Bourget, this is Tony Maloney. Can I speak to Dr. Spector?"

"No way."

"Is he asleep?"

"He and his team pulled out last night. Left me with six rooms not rented."

"But I thought they were going to stay another two weeks."

"They went to New York to do some TV show. Educational television, I think he said."

"But aren't they coming back?"

"He didn't say. New York called this afternoon and they went after dinner."

"Is the Collection still all right?"

"I guess so. It's still out there, is all I know."

"It hasn't rained, has it?"

"No."

"All right, Mr. Bourget. I'll call again tomorrow. Good night."

It was two o'clock in the morning. The city slept. As he stood in the silence of the hotel sitting room, it came to him that all that he had fled and all that he sought was at one and the same time inescapable, unattainable, incapable of change. His manner of falling in love with Mary Ann was another symptom of his curious fate. There could no longer be any real life for him—no life at all apart from the Collection. There would be no new dream, here or elsewhere. Even sleep might be impossible, away from Carmel. And so, sensing some ultimate defeat, he did not even go into his bedroom, but, as

166

though willing his worst fate, stripped to his under-shorts, turned on the television set to a series of silent images and, like a prizefighter awaiting the bell, sat down in an armchair, arms slack, facing the set.

And so, he who had feared the television dream, who had fled across a continent to escape it, now sought to reinstate it in the city of his birth. He fixed his eyes on the soundless flow of images of a late-night movie, will-ing them to disappear and be replaced by the gray, televised booths and stalls, by the monitor camera's unremitting scrutiny of the Great Victorian Collection.

It did not happen.

Far away, a siren cried in the night as an ambulance rushed across the city. He heard it like a knell. Sleepless, his body abused by drugs and alcohol, would he, like others who could no longer dream the dreams which had made them famous, end his days in a madhouse or lie in a suicide's grave?

At 4 A.M., while he was still sitting staring at television, the images were replaced by a test pattern. He stood, went to the set, and turned it off. He was the prisoner of what he had wrought.

Better to go back at once.

At seven, wearing trousers and a shirt, he knocked on her door.

"Mary Ann?"

She opened to him, looking sleepy and touching in her white cotton nightgown. "What's wrong?"

167

"Can I come in for a minute?"

"Sure."

Blinds had been drawn in her bedroom. She had switched on a bed lamp on awakening. Now, in the small pool of lamplight, she moved toward the bed and got in, pulling the sheet up to cover her body. "What time is it, Tony?" she whispered.

"About seven. We'll have to go back to Carmel."

"Oh? Why?"

"I didn't tell you before," he said, "but I haven't slept since I left. I've been awake more than sixty hours."

"But you slept in L.A."

"I lied to you."

"So you weren't even sleepy," she said. It was a statement, not a question.

"I tried pills, booze, everything. But it's no use. It's as though I can't sleep when I'm away from the Collection."

Coloring suddenly, she said, "What about sex?"

"What?"

"Sex. It makes people sleepy."

"Oh? Yes, I suppose so."

"Well, then?" Tossing her mane of hair, she stared at him, intent, expectant. Uneasy, he hesitated, studying the backs of his hands.

"Tony, there's something wrong with me, isn't there?"

"Wrong with *you?* What gave you that idea?"

"First Fred and now you. Why don't you want to sleep with me?"

"Fred?"

"Oh, sure. Why do you think he pretends my father is following us all the time? It makes it easy for him to stay away from me."

"So that's it," Maloney said. "Mary Ann, listen to me. You're beautiful. I think I've wanted to go to bed with you ever since I saw you that night—remember, when you wore those Victorian clothes?"

"Listen, you don't have to make speeches. It's like when a person has bad breath. Nobody wants to tell them."

"Oh, please," he said. "Don't cry. You're wrong. Of course I want to sleep with you."

"Honestly?"

"Honestly."

Clumsily she jerked back the sheet and began to lift the hem of her nightgown.

"Wait," he said. "Let me take your nightdress off."

Obedient, she lay back in the bed. He went to her and bent over her, arranging the ribboned, embroidered collar of the nightdress to present an image of Victorian innocence. Then stood back, looking down at her. Exhausted, trembling, at the end of his forces, he summoned up those first erotic memories of her, recasting her in the rooms of the Collection where he had seen her naked, reliving his fantasy of her as a serving girl— innocent, gentle, frail—lying now on her attic bed, obedient to her employer's lust. Slowly, like an actor playing a role, he dropped his trousers and pulled his shirt over his head. Naked, he bent over her and, his confused, weary brain heating to his imaginings, undid the collar strings of her nightgown and drew it down about her shoulders, revealing her splendid breasts, the nipples erect, hard to his touch. Slowly, almost reverentially, he stripped the nightgown down to her ankles and turned her on her side, his hands caressing her from neck to thigh. And, as he did this, trembling, excited, suddenly she reached out and took hold of his penis. She

169

was real, no dream, she was Mary Ann, awkward in her youth, urgent in her desire, who now began to jerk his penis up and down as though warning him of desperate needs. And so, as he was and always would be, a dreamer, this reality undid him. No longer a man and maid in those far-off wicked times, they were now equals, contestants, almost enemies. In silence they grappled on the bed and in silence, perfunctorily, preliminary, he experienced a brief moment of release. An onanistic moment, he was sure: his awkward partner seemed barely to have begun. Guiltily, he attempted to give her pleasure, but, as if by his untimely climax he had confirmed her worst self-doubts, she pushed him away and sat up, shaking her auburn hair over her face as though it were a veil of chastity. He felt his eyeballs twitch with tears of pity. She rose and, naked, went abject into the bathroom. The shower ran. He listened. The shower stopped. After a moment, he sensed her return. "If we're going to California," her voice whispered, "let's get ready."

He sat up. "Mary Ann, I'm very sorry. Next time it will be a lot better."

"I'll be ready in half an hour. Better go to your own room and get dressed."

"Maybe we could have some breakfast together?"

"No, thanks, I'm not hungry."

He returned to his own bedroom, dressed, and packed. When he came out into the sitting room her small bag sat by the door, with a note on its handle.

> *Please bring this down when you come.*
> *I'll meet you in the lobby at nine.*

He looked at the bag, and then, as a person might who fears he has forgotten something, went back into her bedroom and stood, staring at the rumpled bed, remembering her tears.

After a while he came out and went to the sitting-room windows, which looked down on Sherbrooke Street. Far below, morning traffic moved in silence behind the Thermopane glass. A gray haze, dirty as a tenement curtain, screened out the sun's rays. He thought of Mary Ann, who had loved the Collection, who had wanted, she said, to be part of it. And, suddenly, he too, wept.

At ten minutes to nine he went down to the lobby. Mary Ann was waiting. In silence they boarded the bus, and sat, silent, as it departed. On the plane, she pretended to sleep.

Vaterman met them in Monterey. Mary Ann ran to him and hugged him. Wary, Maloney offered his hand. "Hello, Fred, how have you been?"

"Busy, busy," Vaterman announced. "Hickman is arranging a fantastic franchise setup, very important for Carmel and the entire region Yorkin is really excited about it. I have been told to write the story and we will front-page it the minute the agreement is signed. Really, it is a very big deal."

He had not, Maloney noticed, responded to Mary Ann's enthusiastic hug. But neither did he seem angry with her. They drove at high speed to Carmel. No questions were asked about Montreal.

"So, you're back." Hickman, in salmon-pink shirt,

stood framed in the motel entrance, surrounded by strangers. The strangers were of middle age. They wore their hair long in the latest style, but without conviction, as though it were a guise of conformity. Similarly, they affected the florid modes of dress currently in vogue. Hickman, beckoning like a tour guide, gathered them about him. "Gentlemen, this is my friend and client, Professor Maloney, creator of this magnificent Collection. Tony, these gentlemen are members of the board of directors of our business consortium."

The strangers, cordial yet distant in the manner of senior executives, came forward with set smiles, hands proffered in greeting. Hands shook his. Almost subliminally, he saw Mary Ann and Vaterman move around the edge of the group and disappear into the lobby.

"Tony, now that you're back, perhaps you can help us. The directors have been looking over some of the items here, but they haven't yet seen the erotic collections, the secret rooms and so on. I wonder if, perhaps, you could take us on a little tour?"

"I'm sorry. Maybe later? I just got in from Montreal and I'm very tired. If you'll excuse me, for now?"

"You do look a bit bushed," one of the strangers agreed. "Rough trip?"

"Yes, it was."

"Okay, you get some rest, Tony," Hickman said. "We're going to have meetings right through tomorrow, so we'll have lots of time to work up a little tour when you're in better shape. Right, gentlemen?"

"Of course."

"Nice meeting you, Professor."

"Great pleasure, Dr. Maloney."

They stood in a semicircle, watching him go, surprised when he walked, not toward the motel lobby, but

down into the parking lot, moving along the main aisle of the Collection.

Yes, there was fading. But it was not, as he had at first hoped, a fading one might attribute to aging, the patina which can make a time-scarred Romanesque statue of the Virgin more beautiful than a similar statue which has survived unharmed. No, there was deterioration: but there was something worse. When, at the end of the main aisle he reached Osler's great fountain, he stared at the large polished blocks of glass shaped in myriad curlicues and pilasters. He turned on the illumination and set the water pump in motion. Water jetted and shimmered over the glass. He was gripped by a sudden unease. He switched off the water and, leaning over the rim of the fountain, stared at some of the lower pilasters. He removed his shoes and socks and waded into the fountain for a closer look. These blocks of glass, real and beautiful, had now, among them, some which did not look real. Eerily, certain of the blocks seemed to have the plastic lightness of Lucite, a substance unknown in Victorian times. Yet they were glass. It seemed to him that these false-looking blocks now stood out as obvious imitations, blatant shams, marring the perfection of the others.

He put on his shoes and socks and went back toward Aisle III, and an exhibit which, he was certain, he had examined closely in the past. This was an ornamental clock, much admired by Mary Ann, on which its maker, Jacob Loudan, had labored thirty-four years. On a smaller scale, but rivaling in ingenuity the great clock in Strasbourg's cathedral, its intricate movements included a scenic panorama of day and night, a perpetual

173

almanac, a belfry with ringers, and a bird organ. Maloney hurried to it because his watch told him he was within a minute of the hour. He stood, waiting.

Yes, it seemed to be normal. The hour sounded, the bird organ trilled, the almanac appeared to be properly set, the registers of the tides, of the moon, of the date and month—all these indices were functioning. Yet, when the little bell ringers came forth from their belfry, something was wrong. The clock, which had performed perfectly, now worked as though a few parts of the mechanism had worn away. The bell ringers slipped as they approached the bell, their hammers striking wild. The little cock on the belfry which flew up at the last chime staggered up, then sank back, as though his ratchet was worn away. At the end of the striking, the bell ringers did not retreat completely but remained half in and half out of their little stable.

He moved on. He stopped by one of a set of pianofortes by Collard and Collard, lifted the lid and played a scale. The piano had been perfectly in tune, but now its pitch was slightly off and the tones muffled, as though the felt on the hammers were in need of replacement. He turned away and saw, high above the parking lot wall, a hand-lettered sign:

GOD ALONE CAN CREATE
Do Not Believe This Lie

The madman was back.

Like a prisoner returning to his cell, Maloney went up toward the motel entrance. Hickman and the members of the consortium were getting into several limou-

sines. There was no sign of Vaterman or of Mary Ann. Weary and sick, Maloney entered the familiar lobby, where Bourget sat like a warder at his desk. He handed Maloney his key. Maloney asked that he not be disturbed, then went to his room.

He locked the door. He stripped off his clothes, put on pajamas, and lay on the bed. He did not even bother to pull down the blind. Had one single night of dreaming the television dream caused this deterioration? Or was it the three sleepless nights of his absence in Los Angeles and Montreal? There was only one way to find out. Through sleep; if he could still sleep.

He closed his eyes. At once, the television screen came onto the retina of his eye just as he had seen it before, hung high in a corner of the room. The camera scrutinized an aisle of the Collection. For thirty seconds it remained stationary; then, with a flick of the blue-gray picture, it passed to another aisle. He lay trapped, monitoring the monitor, forced to watch each aisle until the camera moved on. And so, returned to Carmel, he slept at last. And dreamed, again, the television dream.

Next morning he awoke. The sun shone. He rose and went to the window. The Collection stood. He opened the window, climbed down to the main aisle, and went at once to Osler's fountain. Stepping into the water in his bare feet, he went up to the lower tier of glass pilasters, a tier he had examined carefully the day before. The third pilaster from the left, which yesterday had not suffered from the Lucite look, now had the new, slightly dulled, plastic-appearing surface. He climbed out of the fountain, went at once to the Collard and Collard pianoforte, and played the same scale he had

played yesterday. The notes jangled now, still more out of tune, the sounds still more muffled.

The guards were watching him. He realized he was still in his pajamas. Nodding to them, he retraced his steps, climbed back through his window, and then stood in his room staring down at the Collection. Those tin roofs, those wooden sheds, those gray and green tarpaulin awnings, that hodgepodge of aisles and entrances which, yesterday, had seemed prosaic and arbitrary as a transit camp put up for migrant workers, glittered in this morning's sunlight, remote and mysterious as the minarets of Samarkand. And, looking at it now, he saw it for the first time as it really was: a faëry place, ringed around by spells and enchantments, a web of artifice as different from the reality it sought to commemorate as is a poem about spring from spring itself.

He felt cold. A strange chill emanated from these roofs and sheds. In that moment he passed the bar into a new sea of uncertainty. Until then, he had believed that, by his actions, his inattention, his unworthiness, he could destroy this Collection he had so miraculously and fortuitously wrought. But what if the Collection, singular, faëry, false, had, with true artifice, begun to destroy him?

He looked over at Bluff Road. There were few sightseers. A sheriff's car came slowly down the road and turned in at the motel entrance. Lieutenant Polita got out.

And on the crown of the road there appeared a large hand-lettered sign. Carrying it, eyes dulled, lips moving in a silent prating, came its bearer: the madman.

10

That same morning, when Maloney stepped out from the seclusion of his bedroom, it was as though the world waited his rising. There were the businesslike strangers he had seen yesterday, Dr. Spector and his team of researchers newly returned from New York, Vaterman with a reporter in tow, Lieutenant Polita with a complaint from a citizens' group that the Collection contained depraved items detrimental to the community, Mrs. Bourget to ask what he would like for breakfast.

There was no sign of Mary Ann.

"Where is she?" he asked Vaterman.

"Mary Ann? I don't think she'll be coming in."

"Is she sick?"

"Can we talk about it later, Tony? This is Harold Greenfeld from United Press International. He's interested in doing a story on the reasons for your trip to Los Angeles and Montreal."

"I said, is she sick?"

"She told me yesterday that she doesn't want to work for you any more."

"Ah, there you are, at last!" Hickman, small, hairy, decisive, pushed through the crowded lobby, followed by two men who carried large leather portfolios. "Come on, Tony, you're just in time for our meeting."

"Excuse me a moment," Maloney turned to Vaterman. "Look, could you ask her if she'll have lunch with me?"

"If I do it, will you speak to my friend Greenfeld?"

"Yes."

Hickman seized his arm. "Tony, if we can go into the parlor right away? We've been waiting for you. My associates are just starting our major session, we want to have your views on it."

"Just a minute." Maloney turned back to Vaterman. "Call her now. If you do that for me, I'll do the interview with Greenfeld as soon as possible."

In Bourget's funereal front parlor the businesslike strangers sat grouped uncomfortably close to each other, briefcases open on their knees, some thumbing pocket computers as they compared blueprints and conversed in low, boardroom tones. The two men who followed Hickman and Maloney into the room opened large leather portfolios and placed pencil sketches on an easel. Then the younger of the two took up a pointer and nodded to indicate that he was ready to begin.

"Gentlemen," Hickman said. "Let me introduce Robert Athelston and his assistant Billy Longworth. Mr. Athelston, as most of you know, has designed and built some of the largest shopping complexes and the most important recreational facilities in the country. Bob?"

Robert Athelston smiled in acknowledgment of this tribute. "Good morning," he said. His pointer tapped against the top sketch. "Gentlemen, some of you may recognize this. Certainly Professor Maloney will know it. Professor?"

Maloney, who had been standing near the door, went up and looked closely at the drawing. "It's an altered version of the south portico of the Crystal Palace."

"Exactly. And the Crystal Palace, gentlemen, was the great Victorian exhibition hall, a marvel of its time, erected by the order of Prince Albert, Queen Victoria's consort, to house the Great Exhibition of 1851. Right, Professor?"

At that moment Mrs. Bourget entered with Maloney's breakfast tray. One of the strangers at once leaped up, vacating his seat. "Sit here, Professor."

"Thank you very much."

As Maloney, balancing the tray, sat in the empty seat, Athelston tapped his pointer on the edge of the easel. There was silence in the room. "Now, what I propose, gentlemen, is that we make this portico the trademark by which the Collection will be known all over the world. We would begin by building a replica of this façade at the entrance to what we shall call the Great Victorian Village. From then on, all our print advertising, television commercials, bumper stickers, key rings, or whatever, will feature this portico. It will be the insignia, the trademark by which the Collection is known."

"Excuse me," one of the strangers said. "But I'm not quite clear on one point. Are you going to erect this gate outside the Collection, or outside the Great Victorian Village?"

"That's a good question, Mr. Stewart. The Great

Victorian Village will *not* be at the site of the Collection. Our survey shows that in order to maximize the facilities we plan for the Village, it will have to be close to the freeway system. It will be erected on a commercial site which can be acquired on advantageous terms."

"But how will we tie it in with admission fees at the site of the actual exhibit?"

Athelston glanced nervously in Maloney's direction. "Well, in point of fact, Mr. Stewart, the restaurants, boutiques, motel units, and so on, do not necessarily have to be right beside the original concept or exhibit."

Another of the strangers put up his hand. "May I ask Professor Maloney a question? Wouldn't it be possible to move the Collection from that parking lot out there to some more convenient location, near the proposed new site and close to a major highway?"

"No," Maloney said. "I don't think so. Would you excuse me for a moment? I have to make a telephone call."

Hickman bounded to his feet. "Tony, we don't want to keep you any longer than necessary, but there *is* one big question we'd like to put to you right now. It's a question which was raised in our initial meeting last night."

"All right. What is the question, then?" Maloney said. He should have called her himself. It had been a mistake to let Vaterman telephone on his behalf.

"Well, naturally, the Village itself will be a commercial proposition. But this portico which Bob Athelston has shown us would be a work of art, similar to the stuff you dreamed up. Yet if *we* build it, it will only be a copy, not like the genuine antiques in the Collection. And, in addition, it would be very expensive, right, Bob?"

"Right."

"Now, is there any chance, Tony, that just this once you could dream us up this portico? I've told these gentlemen that, based on my previous conversations with you, I doubt that you'd want to do it. But still, I'm throwing it out as a suggestion."

"Are you joking?"

"Tony, we're just trying to explore every avenue."

They were waiting. He was now in their employ. Sarcasm or anger would merely antagonize them, disqualifying him in their minds as the sort of temperamental idiot they imagined people like himself to be.

"So you're planning a sort of town, gentlemen?"

"No, no, it will be more on the order of a shopping center, a mall with adjoining motels, fountains, restaurants, and a plaza."

"Well, then," Maloney said, "I think you, Mr. Athelston, as an architect, will understand what I mean. All I can do is be faithful to what I know. So if I dreamed this I would almost certainly bring the original structure to life. The south portico alone extended for, I would say, seven city blocks. If I could dream it up, you'd be forced to buy land on a very large scale to accommodate it. And land near a freeway comes pretty high nowadays, I'm told."

"I see," said Athelston. "Of course, we didn't do any on-location surveys at this preliminary stage. We merely worked from drawings and so forth. So, naturally, we had no way of telling that the original structure was that large."

The boardroom murmurs intensified in volume. Heads went this way and that.

"So," Hickman said, "if Tony dreams it up, it would have to be a really big structure, right?"

"Not practical," said one of the businesslike strangers.

"That leads to a further point," said the one called Stewart. "The possible question of censorship. As I understand it, there are things in this Collection which, while they may appeal to a certain audience, nevertheless are not what one would call family-trade items. For that reason alone, it might be better if the commercial investment were minimized, so to speak, at the site of the actual Collection. I mean, in case of censorship action."

"Good point, Mr. Stewart."

Maloney stood. "Well, if you'll excuse me, gentlemen?"

The strangers nodded distractedly. The discussion continued as he left the room.

In the lobby, Vaterman and the man from UPI were nowhere in sight. But Dr. Spector was. "Tony, I have the full team standing by now to tape and film what we hope will be the concluding section."

"Excuse me, Doctor, but I have to make a phone call."

"When I say it is the concluding section, I don't want you to think we're losing interest."

"No, no. Excuse me. Be right back."

She was at home.

"Mary Ann?"

There was a long moment of silence at the other end of the line.

"Yes."

"Did Fred talk to you about lunch?"

"Fred?"

"He didn't phone you?"

"No."

"Well, will you have lunch with me?"

There was another silence. Then she asked: "Did you get to sleep yet?"

"Yes. Finally. Mary Ann, that's what I want to talk to you about. I know I was terrible in bed yesterday, but I hope I'm back to normal now. I want to see you. Please, let's have lunch."

"No," she whispered. "Besides, my dad's coming over."

"Well, what about later?"

"I think I'd better hang up. Goodbye, Tony."

"Wait. Even if you don't want to go out with me any more, won't you stay on as my secretary?"

"I'm sorry. But thanks for everything, okay? And listen, it wasn't your fault."

"Look, why can't we just meet and talk. You said once that you wanted to be part of the Collection. Don't you still want that?"

"Oh, Tony," she whispered, "that's over, don't you see? But, look. Good luck. And good luck with your new dream and everything."

"Couldn't we just meet for half an hour?"

But she had hung up.

In the doorway, Vaterman waited, the United Press reporter at his heels. "Ah, there you are. Ready now?"

"Why didn't you phone Mary Ann?"

"I did phone her. She will come here for lunch with you. I did my part. Now it's up to you to do yours. This friend of mine must talk to you."

"You say you *did* phone her?"

"Absolutely."

"Then she—look, I can't do the interview yet. Sorry."

183

He pushed past them. In the lobby, Dr. Spector waited, standing on one leg, then on another, like a heron on cold ground. "Ready now? Did you make your phone call all right?"

"Can I borrow your car? It's an emergency."

"Of course. But will you be long?"

"I'll telephone you, Doctor. Which one is it?"

"The Oldsmobile on the far side of the street. It would be good if we could have our session before lunch. My people are getting restless."

"I'll do my best, Doctor. And thanks for the car."

Her apartment was six streets away, the upper flat in a four-unit bungalow which was reached by an outdoor staircase leading up to a long outside deck. He and Vaterman had helped her move in. He had repainted the small, impersonal living room and hung curtains on the bedroom windows. Now, as Maloney parked the Oldsmobile in the parking lot and went up the staircase, he noticed that something had changed. There were no curtains. The deck chair was missing; the door to her apartment was ajar. He knocked, then entered. The meager furnishings provided by the management remained: all her gear was gone.

"Mary Ann?"

An empty bedroom, the bed stripped, a Kleenex box in the wastebasket. The closet doors were open, the dress racks a cat's cradle of wire hangers. In the pullman kitchen, all was tidy as never during her occupancy. He touched the gas ring: it was still warm. He went back into the living room, looking for a note. There was no note.

He picked up the telephone. It was still working, but whom could he phone? Holding the receiver, he stared at the wall, searching for the nail on which he had hung a Peter Max print. Yes, that was the place. He was not in the wrong apartment. The receiver continued to give off the dial tone. He replaced it on its cradle, remembering that the woman who owned the building lived on the ground floor. Maybe Mary Ann had given her some forwarding address? He went out onto the sun deck. The sun, warm and seasonless, made the concrete wall hot to his touch. He went down the outside staircase and rang the bell, peering through the glass side panel of the woman's apartment to see if anyone was home. With dismay, he saw several days' mail piled up in the hallway inside the door.

A car door slammed behind him in the parking lot and footsteps crossed the lot. He turned, saw a man's shoes moving on the outside staircase above him, and went outside to look. A red-faced man with a brush cut of gray spiky hair was walking along the upper sun deck. The man dragged his left leg with a pronounced limp. As Maloney watched, he went into Mary Ann's apartment. Two at a time, Maloney went up the stairs and stealthily moved along the sun deck to the open apartment door. The man was in her kitchen. He took a cardboard box from a closet, opened the refrigerator, and began to put pickle jars, a milk carton, butter, and a package of hamburger patties into the box. When he had finished, the man pulled the plug out of the wall and left the door open. Maloney drew back from the entrance, moving out of sight as the man came out of the apartment and put down his cardboard box. From his trouser pocket, the man produced a key and locked the

185

door. Then, as though he had known all along that Maloney was there, he turned, smiled, and winked sociably. "Hi, Professor, how are you today?"

"Are you her father?"

"I'm the father."

"Mr. McKelvey, I must talk to her, it's very important."

The father bent and picked up his carton. "I'll bet it is."

"No, listen . . ." Maloney began, and stopped, unable to say it. The father, red-faced, grizzled, peered at him like some old Alaskan bear, weary but capable of delivering a sudden, wounding clout. "I'm listening," the father said.

"I miss her terribly."

The father shook his head, as though to clear it. "Let's go downstairs and have a snort. I have a bottle in my car."

In the parking lot, a green Chevy sat directly opposite Dr. Spector's Oldsmobile. The father opened the Chevy's front door and took a bottle from the glove compartment. He held it up to the light, revealing only a finger of Scotch. "Son of a gun. Thought there was more. Tell you what. Let's go and pick up a crock and go to your place. I imagine you'll want to have a talk."

"All right," Maloney said. If he got this old man drunk, he might loosen him up on her whereabouts.

"You take your car and I'll follow in mine. Okay, Professor?"

Maloney got into the Oldsmobile and drove back to the Sea Winds Motel. The Chevy, wavering a little, followed him uncertainly. As Maloney drove in at the motel entrance, Hickman and his associates were installing themselves in their limousines. "Hello there,

Tony," Hickman called out. "We're just going off to look at a couple of sites. Why don't you join us?"

Maloney declined. Dr. Spector came out from the lobby, anxious, but polite as always. "Ah, you're back. I hope everything's all right?"

At that moment the green Chevy moved through the front gate, cutting perilously close to the limousines. The father leaned out of the window. "Hey, we forgot the bottle."

"I'm sorry," Maloney said.

"It's okay, I'll go down to Ocean and get one. Be right back."

"Perhaps we can start the taping session now?" Dr. Spector suggested.

"We could start, I suppose," Maloney said. "But I have to see that man when he comes back."

"Well, if we can get started, it will be a great help. If you'll come with me?"

As they went toward Dr. Spector's suite, Maloney saw Vaterman closeted in the public phone booth. Angrily, Vaterman jerked the door open. "You really screwed me up, didn't you! You ask me to do publicity for you and then you treat a top wire-service reporter as if he was dirt. That is one hell of a lousy thing to do to me."

"Mary Ann has gone," Maloney said.

"Mary Ann, Mary Ann! That's all you ever talk about. She is *my* girl. Let us get that straight, right now."

"She's nobody's girl," Maloney said. "She's disappeared. Her apartment's been cleaned out."

"Nonsense."

"Go and see for yourself."

"*If* you please, Tony," Dr. Spector said, nervously. "We're ready now."

"Right," Maloney said. He went into the suite, leaving Vaterman outside.

A man with an Arriflex camera moved up to face him. Tape machines whirred. "Interview 8. Subject and Spector. Take 1," Dr. Spector declaimed. The camera turned.

Ten minutes later, during a break to load new film, Maloney looked out of the window and saw the green Chevy parked at the front entrance. "I'm sorry," he told Dr. Spector. "I have to speak to that man. I'll come back as soon as I can."

"Not too long, I hope?"

"I hope not," Maloney said.

He went out to the front where the father, his gaze somewhat unfocused, sat in the Chevy, an opened bottle of liquor in his hand. "They told me you were busy with an interview or something. So I've had a couple of snorts. I got you Canadian Club, is that okay? You *are* Canadian, aren't you?"

"Let's go into my room, then," Maloney said.

"I think about things like what brand to buy," the father said, "because I was a supply sergeant. I managed PX stores. Mostly overseas. Twenty years in the service but, like they say, I never fired a shot in anger."

They went to Maloney's room. "Did Mary Ann travel with you, overseas?"

"Some. Her mother died when Mary was just a baby. I had to be father and mother to her. Do you have kids yourself, Professor?"

"No. Do you want water?"

"I take it straight." The father sat heavily on

Maloney's bed and poured. "It's not easy, let me tell you. A girl who looks like that, you've got to keep tabs on her."

"Did you follow us to Los Angeles?"

"Vaterman said I did, didn't he?" The father began to laugh, but the laughter collapsed in a fit of coughing.

"I just want to talk to her. Surely you've no objection to my just having a talk."

"You're too late."

"Why?"

"Because she's free now. Free from all of us."

"Oh, my God," Maloney said, suddenly afraid. "What's happened to her?"

"Have a drink."

"I don't want a drink. What have you done to her?"

"Now, don't get a dirty mouth on you," the father said. "That other sonofabitch, trying to make out there was something between me and Mary. Mess with my own daughter. Jesus Christ! I'm her father and I love her like a father. That's why I'm helping her now."

"How are you helping her?"

The father filled their glasses. "I let her go," the father said. "I put her in a cab to the airport. She's gone."

"She took a flight. Where? Overseas? Back East?"

"Yes, she took a flight. But that's all I'm going to tell you, Professor. So don't ask any more."

"I miss her," Maloney said. Suddenly he felt he would weep. "I don't know what I'm going to do without her."

"You'll get over it. Fellows like you must be in love with yourselves. Otherwise, why would you dream up things to make the world take notice of you?"

"Mr. McKelvey, my dream was an accident. Believe

189

me, there's nothing I'd like more right now than to go back to being an ordinary teacher."

"But you can't, can you? Besides, I don't think you'd ever have been right for my Mary."

"But she liked me. And she admired the Collection."

The father sighed and stood. "I'd better be moving along."

"Look, if I give you a letter addressed to her, will you deliver it?"

"No."

"Why not? Just one letter?"

"Listen to me," the father said. "Yesterday I went to the bank and signed a note for Mary. Ten thousand dollars. And when I gave her the money I didn't ask her where she's going or what she's going to do. I'm helping her get away on her own. That's a father's love. You wouldn't know anything about that."

"So you don't know where to reach her?"

"Correct. I don't know what plane she took this morning. And I don't want to know."

"But she might write to you?"

"She might."

"Well, if she does, will you forward a letter for me? Please?"

"Better keep the bottle," the father said. He turned toward the door. "The bottle helps. For a while."

"It will take me two minutes to write a letter. Just a short note? Please?"

"Have a nice day," the father said. The door shut.

Maloney rose to go after him, but staggered as the ground, at first very far away, came suddenly close. He sat down, clumsily, on his bed. He was not a drinker, not at all, but in his eagerness and excitement he had drunk down a huge glass of whiskey as though it were

Coke. His head seemed to expand as the whiskey assailed his senses. He sat, staring at the floor.

Someone knocked. Then a second, urgent knock.

"I'm coming," he called, rising unsteadily.

The visitor was Vaterman.

"You're right, Tony, she *has* gone. I have been all over Monterey, I spoke to Mona, her girlfriend, I checked at her flat and with the rental company that leases her car. She gave up the car this morning. Nobody knows anything. It has got to be the father. He has taken her some place. Maybe against her will."

"It's not the father," Maloney said, with slurred deliberation.

"You don't know him. He is tricky."

"He was here a few minutes ago."

"He was here? You *saw* him?"

"He brought this whiskey. Do you want a drink?"

"What did he say?"

Maloney told him.

"He gave her *ten thousand dollars?* Do you mean to tell me you believe that?"

Maloney rose, rinsed out the father's glass in the bathroom, and poured two whiskeys. "Here. You'd better believe it too."

Vaterman took the glass but suddenly put it down untasted. "This is all your fault," he said in a high, angry voice. "I never should have got mixed up with you. I always knew there was something phony about your story. If I had been a better reporter, I'd have kept on digging until I got to the bottom of it. You didn't fool very many people, you know. Even now, most newspapermen believe you are a phony. Phony Maloney. I remember that remark your mother made about you being a practical joker, don't think I've for-

191

gotten that. I am too trusting, that is my problem. What a fool I was, letting the pair of you go on to Montreal. I lost my girl because of it."

"I'm sorry. I know how you feel."

"No, you don't. Trouble with you is, you have no idea what other people feel. All you think of is that damn Collection. What a joke! The Great Victorian Collection. Never mind whether you dreamed it up or not, have you ever listened to what serious people say about it? Why, they say it isn't relevant, it's completely out of date, it has nothing to do with our contemporary reality. That's what they say and they are right."

"Who says?"

"People who know. People who are not taken in like I was. And, my God, was I taken in. Do you know what you are, you're a fraud, you are not a dreamer at all, all you are interested in is stealing other people's girls, getting her to go to Montreal with you under false pretenses, and then making passes at her, you pig—"

Suddenly beside himself, he turned on Maloney, who sat on the bed, a drink in his hand. Vaterman's claw fingers struck out at Maloney's face. Whiskey spilled on the rug. "What did you do to her? She came back completely changed!"

"Wait, wait," Maloney said dully, putting his arms over his head to protect himself as Vaterman, standing above him, let loose with further blows. "Listen, Fred. She wants to get away from all of us."

"Don't you dare talk about her, you pig!" Vaterman shouted. "I am through with you. You can take your lousy job and stick it. Great Victorian Collection! It is a flop, a bust, a collection of old junk nobody cares about, out of date before it's even shown. Imagine asking the public to pay to see this crap. And what about those

192

other dreams you were supposed to have? Listen, you. You think you got away with it, but you didn't. Deep down, nobody ever did believe it. And now, by God, if it's the last thing I do, I'm going to show you up to the whole world for the damned fraud you really are!"

"Fred, look, just a minute—"

"Don't 'Fred' me! You go to hell!"

The door slammed shut. Maloney got to his feet, dizzily. It was as though the shouting and the blows had emptied his mind, leaving him too weary for anger or disgust. Instead, a drowsiness came upon him, a noon drowsiness which at once overwhelmed him. He felt his eyelids droop. If he fell asleep now, in the daytime, he might not even dream.

Yawning, almost asleep, he went to the telephone.

"Mr. Bourget. Maloney here. I don't want to be disturbed by anyone until further notice."

"But what about Dr. Spector? He's waiting for you."

"Not even by Dr. Spector."

He lay down. Without any warning, he fell into a stuporous slumber. He slept on into the afternoon, in heavy, narcotic, dreamless ease, until, sometime before dark, he shifted in his sleep and began to dream.

It was not a new dream. It was the television dream. But he dreamed it as a drunk man dreams, disconnectedly, unaware, in the stopped clock of intoxication, of those inexorable waits before the camera shifted surveillance from aisle to aisle. He guarded the Collection as a drunk guard might, surrealistically irresponsible, the camera dancing up and down those gray aisles. And so, for the first time, the television dream became a fitful, inconsequential fantasy. He slept on into the

night and woke before dawn, dry-mouthed, hung-over, but still drunk.

At 5 A.M. he fell asleep again. But now, as his drunkenness decreased, the television dream righted itself. The camera held long and steady on each aisle. For the last two hours of his sleep, he suffered the familiar torments of the surveillance dream.

He woke at seven. At eight, Dr. Spector called. An hour later, the final interview in the Vanderbilt Series was filmed and taped. In the *Journal of Parapsychology,* Vol. XX, No. IV, this note occurs in Dr. Spector's summation of that interview:

A discernible difference was evident in the subject's behavior in this final filmed interview. Agitation which had been remarked on previous occasions and which had been particularly evidenced in the three preceding sessions was markedly absent. Toward the end of the interview, on being questioned about the apparent change in his attitude, the subject made the following observations.

M A L O N E Y . Well, I suppose I've accepted it. I've faced up to what's happened to me. There's a certain calm in knowing the worst.

Q . The worst? Could you explain that, a little?

M A L O N E Y . Well, I used to think that, because I dreamed up the Collection, it belonged to me. I was responsible for it. But now I'm beginning to think it's the other way around.

Q . I'm sorry. I don't quite understand.

M A L O N E Y . Well, if something you dream up comes

to life, it stands to reason that it develops a life of its own. And now it's taken me over.

Q. In what way?

MALONEY. It's cut me off from my former life, from my job and so on. I can't even plan any future. I'm a prisoner. The only way I could leave, I suppose, would be if I could dream a new dream. And then I'd probably become the prisoner of the new dream.

Q. You mentioned earlier that you find it exhausting to dream the same dream night after night. Have you ever considered some mind-altering process? Perhaps the use of an hallucinogenic drug might induce a new dream?

MALONEY. I don't believe it would work. Those things don't produce real dreams.

Q. What about a sedative? Something which would plunge you into a deep, dreamless sleep, blocking your current dream out?

MALONEY. I tried barbiturates in Los Angeles. They didn't even put me to sleep.

Q. Then, in your judgment, there's nothing which will ease for you the nightly ordeal of this dream?

MALONEY. Whiskey seems to help.

Q. You've tried whiskey?

MALONEY. Yes. Look, are there any more questions?

Q. Would you like to stop now?

MALONEY. Yes.

Q. Fine. Well, this was our final interview. Thank you, Tony.

MALONEY. Thank you, Doctor.

11

Six months later, a traveler on the highways of California approaching Los Angeles, San Francisco, the gambling cities of the desert, or remote national monuments such as Joshua Tree or Death Valley, could not fail to see a sign, positioned at fifty-mile intervals. Beneath a simplified drawing of the south portico of the Crystal Palace was the legend:

VISIT CARMEL-BY-THE-SEA
Home of
THE GREAT VICTORIAN COLLECTION

There was no need for further information. Hickman had copied this form of advertising from Disneyland. Disneyland is known. It is not necessary to explain what it is in billboard advertising. Similarly, as Hickman had foreseen, the Collection was becoming known. However, it began its life as a public exhibit in an atmosphere of confusion concerning its claims. Dr. Spector's

196

team continued its guarded inquiry without, as yet, having published any conclusions. Other kinds of experts—historians, antiquarians, collectors—remained interested but tended to ignore its supernatural aspects. As for the general public, most people visiting the Collection accepted with a mixture of embarrassment and amusement the explanation that it had been dreamed into life. Some, a definite minority, were filled with envy and curiosity and wanted to meet Maloney and discuss dreams of their own. As for the news media, they had long since passed on to other stories, leaving coverage of the exhibition to popular weeklies and Sunday supplements, which, starved for marvels, tended to write almost uncritically of the dream aspect.

Initially, it seemed that the Collection would be a great success as a public exhibition. Advance requests for tickets were impressive. However, following public announcement by the State of California that the Correction Chamber, the bordello parlor, the erotic library and collection of pedophilic photographs, would remain closed to the general public, ticket sales dropped sharply. Hickman's consortium at first protested this decision, claiming that they, as co-exhibitors, had been robbed of the Collection's greatest drawing card. This protest was dropped abruptly when the consortium learned that diminished attendance at the Collection itself had actually resulted in a gain of admissions to the Great Victorian Village, three miles east of the Collection. The Village, an impressive construction wholly owned by the consortium, comprised three hundred motel units and two shopping plazas which housed a number of emporia decorated in the Victorian manner. The prurient were wooed in Mrs. Beauchamp's Parlour, a nightclub decorated in a bowdlerized version of the

Collection's bordello, which had been closed to the public because of its bestial wall decorations. In Mrs. Beauchamp's Parlour, young California girls wearing black lisle stockings and white cotton knickers with panels which opened to expose their behinds moved among the patrons, serving drinks and flaunting their breasts in provocative deshabille. There was also the Penny Gaff, an imitation Victorian music hall, with low comedians, topless can-can dancers, and three nude girls in red silk stockings who sailed over the heads of the audience in red velvet swings, their bare bottoms elegantly cushioned on white swansdown seats.

There were, in addition, two large family restaurants, the General Gordon and the Gladstone; a food market named Covent Garden; and a number of shops, including the Olde Curiosity Shoppe, the Florence Nightingale Tea Room, Oscar Wilde Way Out (a men's-wear boutique) , and, finally, a large warehouse supermarket filled with cheap reproductions of Victoriana and misleadingly named the Great Victorian Collection. The whole was fronted by an altered scale reproduction roughly corresponding to the south portico of the Crystal Palace.

Indeed, as the months passed, it became apparent that, of the thousands of tourists who came to Carmel to view the Collection, a surprising number spent most, if not all, of their time in this Village, and, as Maloney was to discover, many of them believed that the warehouse supermarket in the Village itself *was* the Great Victorian Collection.

Maloney rarely visited this Village. He continued to reside, close to the original Collection, in his motel room in the Sea Winds Motel. Responsibility for maintenance and upkeep of the Collection, including guard

patrols and guide duties, had been assumed by the California Parks Service. In conjunction with the Hickman consortium, the Parks Service had erected here a second, still smaller replica of the Crystal Palace south portico. This modest entrance facility contained ticket booths, toilets, and a lounge in which tourists assembled for guided visits.

These visits were conducted by Parks Service rangers, wearing their regular khaki uniforms, polished riding boots, and scout-type campaign hats. Hickman referred to them as "Smokey Bears," a disparaging reference to the cartoon bears in ranger uniform used on fire-warning posters. But Maloney liked them. They were, after all, people he saw every day. They frequently sought his advice in answering questions put to them by their tour groups. Trained as rangers, they were invariably courteous and respectful and were in the habit of saluting when their paths crossed his.

After the first few weeks of the Collection's exhibition, Maloney laid down a rule that he was not to be pointed out to the tourists. The small gratification of being recognized by strangers quickly evaporated when this became a daily occurrence and when the tourists, in the manner of tourists everywhere, pestered him with requests for information and autographs, and asked him to pose for photographs with their group. But when news of his decision reached Hickman and the director of the California Parks Service, efforts were made to have him change his mind. A survey carried out by the Service had indicated that the most frequent request made by visitors was to be shown the room in which the original dream had taken place. The second most fre-

quent request was to be allowed to meet, or at least to catch sight of, the creator of the Collection.

"Just four times a day for as little as five minutes, and revenues would triple, I guarantee you," the director said.

"But this isn't a circus. I'm not a freak, I'm an ordinary person. It's what I've done that's extraordinary. The Collection is what counts. If you carried this thing to its ultimate conclusion the public would lose all interest in the Collection itself."

"Exactly right," Hickman said. "That's what's happening here. Face it, once the Parks Department closed off the hot parts, how many people do you think still want to come down here to look at the rest of the stuff? Don't misunderstand me, Tony, I'm not knocking your Collection. It's just that very few people are interested in art works of any kind. What they want is a show, something spicy and interesting. That's what we're giving them down at the Village. The one thing we can't give them down there is you. Everybody would like to meet a guy who made his dream come true. You're what people will come here to see."

"All right, but what will they think when they do see me? I'm not an interesting person. In fact, it's probably because I'm not interesting that I became a dreamer and dreamed this stuff."

"Well, of course, ultimately it's up to you," the director said. "If your privacy is that important to you, I withdraw my suggestion."

"Just a minute," Hickman said. "Let's not abandon the plan altogether. Why don't we review it two months from now? And, in the meantime, I've got an idea. All these motel rooms look much the same, so let's furnish one of them with some books and stuff and exhibit it as

Tony's dream room. That way we can at least add *something* to this setup."

This was done. But the question of Maloney's making personal appearances was not raised again. For, by the time two months had passed, his condition had deteriorated to the point that the tour guides, if they saw him approach, would turn their groups into another aisle.

It was about this time that Maloney began the intimate journal from which Dr. Spector later published excerpts, as an appendix to Spector's long article: "Psychokinetic Elements in the Manifestation of Dreams: The Carmel Experiments," which appeared in the *Journal of Parapsychology*, Vol. XX, No. V.

In his preface to this appendix, Dr. Spector notes: "At first, the diary would seem to have been compiled for the subject's private use, as a listing of certain tasks which he had been able to accomplish. Entries consist of a few lines written after each date, viz.:

APRIL 21.
TV dream three hours? Wrote Mother A.M.
Answered Smithsonian catalogue inquiry.
Night: Exercised on beach, midnight to 3 A.M.

"But, two days before the anniversary of the Collection's appearance, the style changes. As will be seen, the subject now seems to be trying to communicate his experience to some eventual reader of these lines."

MAY 8.
I have been reading about nightmares. Doctors say a dream is a nightmare when it is so unbearable that the

dreamer is forced to wake from it. That is what happens to me. I wake, every night, from the television dream, screaming, my throat raw.

When that happens, I get out of bed, go to the middle of the room, and stand there, hour after hour, until other people wake up. As long as I remain standing, I don't fall asleep and so am spared the dream. This morning I stood until 8 A.M., when I heard Mrs. Bourget's clock radio down the hall. Then I went to the bathroom and took a shower. I stood in the shower thinking of people I'd known as a child, trying to remember the look of certain streets and the furniture in certain rooms. When the shower ran cold, I realized that, once again, I'd been standing for a long time doing nothing. I no longer worry about wasting time like this. At least, I hadn't fallen asleep again. So I counted it a victory. The morning, I mean.

But then I made a mistake. When I had shaved, I went back into the bedroom to get dressed. I passed near the window and was not on guard and so looked out. Weeks ago, I don't remember exactly when, I woke up with a hangover and for some reason went until about four in the afternoon without doing what I usually do as soon as I wake, which is go to the window and look out to make sure the Collection is still there. But that morning I forgot. And so for some hours I remained in the state of mind I used to know long ago. I was not in a state of anxiety. I did not think about Mary Ann. I did not think about my former life. And, most of all, I did not think about what is happening to the Collection. And so I have begun to want that state of forgetfulness as I never wanted any other sensation. Sometimes I manage to drift through a few hours each morning without thinking of the Collection. But, as soon as I do,

I am drawn to the window. And when I look out and see it there, in the parking lot, I behave like a sleepwalker, in a trance. I open the window, climb out, and go down to wander in and out of the aisles and booths. And then I am undone. My day falls down about me.

For something terrible is happening to the Collection. Several terrible things, in fact. There are the cases where the original materials now seem false. And other cases where actual damage has clearly occurred. The fountain, for instance, Osler's great crystal fountain: those perfect blocks of polished glass are now mostly dull, light in weight, dead as plastic. They may not be Lucite, they may still be made of glass. But they feel and look like Lucite, not glass. It's the same with the silverware. The hallmarks have faded completely, so that I can't tell any more whether it's silver, or silver plate. The Staffordshire pottery has lost its glaze: it looks imitation. But in most cases it's not change but simple damage, though where it comes from, I don't know. The Parks Service has erected very sensible overall roofing which completely protects the aisles and booths from rain and sun. Yet, the machinery either warps or breaks down, the canvas cracks, the furniture stuffing appears, the toys don't wind, the dolls' eyes no longer move, the damask and linen have brown stains, I don't know where they come from. I won't try to describe the deterioration of the marquetry furniture, bookcases, and escritoires. Let's just say that doors don't close, the wood has swollen, the drawers stick. The statuary has developed cracks, even in the cast-iron pieces. The musical instruments all give out false notes, there are mysterious bare patches on the collection of sables and ermines, the Ross telescope lens is misted, I've polished it a dozen times, but it does no good. The Folkstone

locomotive has one wheel badly buckled, making the whole engine tilt as though it's been in an accident. Why go on, the simplest way to put it is to say that nowadays, if I stop and examine any item in any collection within the Collection, chances are that there's something wrong with it, some breakage or other defect that definitely wasn't there six months ago. The Collection is deteriorating, and the deterioration is getting worse.

You might ask why I care? I mean, didn't I do my best to get rid of the Collection, didn't I try to run away from it, don't I suffer nightmares every night because of it? All that is true. I know this deterioration is not my fault. I've done my best. I gave up my job, Mary Ann, everything, to stay here and look after it.

So it's not my fault if it's deteriorating; is it?

MAY 15.

I feel sick, most of the time. I drink to get through the day. I have taken to hiding from other people. When I wander the aisles of the Collection and see a tour group coming, I at once hurry into one of the prohibited rooms like Mrs. Beauchamp's Parlour, or the Correction Chamber. Sometimes I spend hours in the Correction Chamber, not because I am particularly interested in cruelties, but because it is so private, so hidden away from the rest of the Collection.

Of course, it is becoming as painful to linger there as it is anywhere in the Collection. The wooden benches have warped, the whips and hairbrushes are losing their thongs and bristles, the flogging-horse padding is moldy and limp, the punishment costumes are mildewed and eaten by moths. In the flagellation library, the books suffer continuing damage. Spines have loosened, the

edges of the pages wilt, the bindings have weakened and lost their glue, so that, when I handled a beautiful volume of Villiot's La Flagellation Amoureuse *the other morning, its pages scattered like confetti and I spent an exhausting two hours picking up and rearranging text and illustrations.*

Still, I seem to suffer less from anxiety in this room. I think it's because very few people have seen it as it was before its deterioration. This is not true of the rest of the Collection. I suspect that the tourists know *what is happening. From my hiding places I peer out at them as they come along the aisles. First comes the guide, who stops, waits for them to assemble in a semicircle around him, lectures, then moves on. The tourists follow, straggling, gossiping, to reassemble again at the next lecture point. I study their bored faces. I know that, like tourists everywhere, they know nothing of what is being told to them. But I would guess that even the most mindless of mobs can sense the difference between those things which have endured for centuries and those which will not last out a lifetime. Unlike the great places of antiquity, the Collection does not stand aloof, indifferent to philistine scrutiny. Rather, these objects which I love seem to entreat the tourists' attention and respect. And fail. I can foresee a time, not far away, when very few tourists will bother to leave the Great Victorian Village to come up the road and look at my Collection.*

MAY 19.

There is an armchair in the Correction Chamber which, at the touch of a concealed spring, suddenly sprouts iron bands which bind the unsuspecting victim hand and foot. It was designed as a "seducer's chair" by Charles

Everett, a notorious London rake. The other day, touching the spring, I saw that the mechanism had rusted and no longer works. Since then, I have taken to sitting in this chair. It is very comfortable. Last night, having drunk more than was good for me, I came down here with the idea of trying to sleep in it. I had some confused notion that if I fell asleep inside *the Collection, I might not dream the television dream.*

The experiment did not succeed. I did not sleep a wink. In addition, I felt more anxiety than if I were standing shaking in the middle of my motel room. So, after a few hours, I left and went back to my own room. I lay down and, as usual, dreamed the television dream.

MAY 22.
I have not spoken to Hickman in two months. As my agent, he used to call every other day. And I have not seen Vaterman since the day he left here, shouting out that the Collection was a flop. Strange, I wouldn't mind seeing Fred again. I wonder what has happened to him? Is he still on the Monterey paper? I could phone. But I suppose I won't.

MAY 26.
Maybe Fred has had news of Mary Ann? I might call him tomorrow, if I feel better.

JUNE 13.
Ten days ago I was wandering around drunk among some garden furniture designed by William Robinson and Gertrude Jekyll. I bumped into a terra-cotta urn, fell down, and sprained my ankle. A doctor was called in, and in the course of examining me, he told me I am

suffering from hypertension and described my condition as "one of exhaustion." I was struck by the phrase. I tried to explain to him, guardedly of course, about my sleeping problems.

"What about sleeping pills?" he said.

At first I resisted, explaining that I am trying to create a new dream and I suspect it will not come to me under the influence of drugs.

"Then why do you drink?" the doctor asked. "Alcohol is a drug, and a dangerous one."

I had no answer to that. I did say that I drink to get through the day.

"Tranquilizers would be better," the doctor said. "The way you're going now, you're simply killing yourself. Also, if you don't mind my saying so, you spend too much time in this room. You need other interests besides this work of yours. Do you have a girl?"

I felt tears come into my eyes when he said this and, to conceal them, pretended to blow my nose. But the doctor was not deceived. "You see," he said gently. "You're under a strain. You're emotional and easily upset. I'm sorry, but I do feel it's urgent that you make some effort to get yourself together again."

"Maybe I'm Humpty Dumpty," I said.

"What did you say?"

"Sorry. Nothing."

The doctor then wrote on his pad and tore off a sheet of paper. "Well, here you are, then. Get this filled. Better for you than all that schnapps."

I mention this visit from the doctor because it brought me to my senses, so to speak. Although I had the prescription filled, the bottle of pills stands unopened by my bed table. I have reduced my drinking to

one Scotch before lunch and two before going to sleep. I make it a point to answer my mail and to assist those scholars who are writing papers on various aspects of the Collection. I have again begun to read. At the moment, you might say, my life is devoted to improving my life. It is, I find, a full-time occupation.

Three weeks later, there is a further entry.

J U L Y 3 .
Perhaps this is a good time to make a progress report. Although I've had a few relapses, I no longer suffer nightmares. I dream the television dream, but somehow I seem able to bear it. I sleep all night, so I am feeling less exhausted. During my first relapse I made my one and only use of the sleeping pills the doctor prescribed. They didn't help and I am not tempted to continue with them. I find that I cannot be "tranquilized" simply by taking pills.

J U L Y 9 .
Progress report. I try not to visit the Collection. I have not gone out there once in the past three days. I tell myself that its deterioration is something that cannot be stopped. There is no point in my becoming upset about it. It is, perhaps, an intermediate step in my development. Now I must work toward a new dream, a dream which will be more permanent than the Collection. I understand what is needed. All I have to do is cut down on my drinking, avoid nightmares and, above all, concentrate. I must prepare my mind to break through to a new threshold of dream.

A week later, there is a one-word entry.

JULY 16.
Nightmare.

Four days later, there is this entry.

JULY 20.
Today I found myself forced to return to the Collection.
I sat for hours in the Correction Chamber.
 Perhaps I will not be able to dream a new dream
until the Collection has deteriorated completely and is
carted off as rubbish?

JULY 21.
The television dream again. I woke, screaming
 I have made no progress. I must face that truth.

On the afternoon of July 25, Park Ranger William
Hutton, who was conducting a group of tourists
through the Collection, came to the booth containing
the W. Hunt & Son exhibit of double damask linen
manufactured for Queen Victoria for her use in the
Highlands. Kneeling before the damask display, fanning
it with a lighted sheet of newspaper, was the creator of
the Collection. He was attempting to set the booth on
fire. "He was drunk," Ranger Hutton later told Dr.
Spector. "He kept waving the flame about over the
damask, the frames, the whole stall. 'Look at that,' he
said. 'It's not flammable, none of it is flammable. It
should be flammable, but it's not. It's not permitted, do
you see?' "
 Hutton telephoned the main gate. Two rangers were
dispatched to the booth, where they extinguished the
flames and assisted Maloney back to his motel room. He
was incoherent and appeared intoxicated. He did not

order dinner that night or leave his room until the following morning.

Two days later, there is a brief entry.

JULY 27.
Having tried fire, this morning I attempted force. I used a hammer, but was unable to shatter a single fragile piece of the Staffordshire.

On July 31, at four in the morning, Paul Bourget, the nineteen-year-old son of the motel owner, who was visiting his parents on vacation from college, wakened and heard a noise outside his room. He looked out of the window and saw Maloney, wearing only pajama trousers, standing in the center aisle of the Collection. He had just switched on the illumination for the Osler fountain and now he waded into the fountain pool and attempted to set the water mechanism in motion. It did not work. Maloney tugged at the levers for a moment, then, abandoning his efforts, stood dejected in the fountain pool, not moving, staring up at the imposing, brightly lit tiers of glass. The temperature was in the low forties and there was a fog coming in from the ocean. Young Bourget, remembering his father's worry about Maloney's recent drunkenness, dressed and went down into the parking lot.

In his report to Dr. Spector, young Bourget said: "He was standing like a soldier at attention, shivering, and he looked right at me and didn't see me."

The young man asked, "Are you all right, Professor?"

"Yes," Maloney said. He did not seem drunk.

"Kind of chilly, isn't it?"

"The way I feel, I'd welcome a chill," Maloney said. "In fact, I'd prefer pneumonia."

Young Bourget, not knowing what to make of this, took cover in laughter.

"I'm serious," Maloney said.

Young Bourget did not reply but, guided by some innate tact, helped Maloney out of the fountain and led him back to the motel. In his own bedroom, Maloney refused to sit down. Young Bourget said that he left Maloney standing in the center of the bedroom, staring in the same sightless way as before.

On the following Sunday, this notation was scrawled in the diary in a large, loose hand, unlike Maloney's small, careful script.

AUGUST 4.

Perhaps the way to break through is through unconsciousness itself?

On that day, a normal Sunday, usually a slack time, as most tourist groups leave after lunch in order to return home by Monday morning, Maloney was not seen in the lobby or on the grounds. Nor did he order any meals to be sent to his room. On the following day, Monday, he did not call the switchboard to order breakfast. At 10 A.M. there was a long-distance phone call from Hickman in New York. When Maloney failed to answer his telephone, Hickman gave instructions that he was to be awakened.

The elder Bourget went to Maloney's room. The door was locked. Using a passkey, he entered the room.

The blind was not drawn. Maloney was sitting in an upright position on his bed, fully clothed, his head resting against the headboard, staring out the window. "He looked as if he'd just seen something," Bourget said. "Matter of fact, I went and looked out the window myself, thinking maybe something was wrong. But it was just the usual. The guides had three tour groups going the rounds. I looked back at the Professor—I was going to speak to him—and all of a sudden I knew he was dead. There was a bottle of bourbon on the bed table, pretty near empty, and a pill bottle with some pills spilled across the bed. I picked up the phone and called the doctor."

Within the hour, the news that Maloney was dead and that the Collection still stood was on news wires around the world. The press descended again on Carmel and for twenty-four hours the event was of front-page importance. Dr. Spector flew in from Vanderbilt University that same afternoon. At the inquest, which was held on the following day, the Salinas County Coroner announced that the deceased had died of an overdose of barbiturates mixed with alcohol. Time of death was put at about ten hours previous to the discovery of the body, which would make it shortly after midnight on that Monday morning.

Dr. Spector at once called in Professor H. F. Clews, of Yale University, for an expert opinion on the condition of the Collection. The Collection, in Dr. Clews's opinion, had suffered some deterioration since he had last examined it, probably as a result of having stood for more than a year in a semi-outdoors, subtropical location. But it was still, essentially, intact.

At the request of Maloney's mother, the body was flown to Montreal, where, after a private funeral, it was

buried in the family plot in Mount Royal Cemetery. Mrs. Maloney refused to make the body available for medical research. Maloney died intestate, but royalties from the Collection are now being paid to his mother, who is his only surviving relative. The royalties in question have greatly diminished since his death. For, while tour groups continue to patronize the nearby Great Victorian Village, paid admissions to the Collection itself are now minimal. The number of guides has been reduced to two. As Dr. Spector wrote in the afterword to his final report in the *Journal of Parapsychology*, Vol. XX, No. V:

"Later, as is often the case in such matters, fewer and fewer people seemed to believe in the veracity of Maloney's account of the circumstances of the Collection's creation. Nevertheless, as our researches have shown, there seems no reason to doubt that this Collection, a duality which exactly reproduces the originals it commemorates, will continue to exist as a minor marvel in Carmel-by-the-Sea, California. The extent to which it will outlive the man who created it, or its interest to succeeding generations, is, of course, beyond the range of our predictions."

Q6